A Drop of Life in the Sea of Time

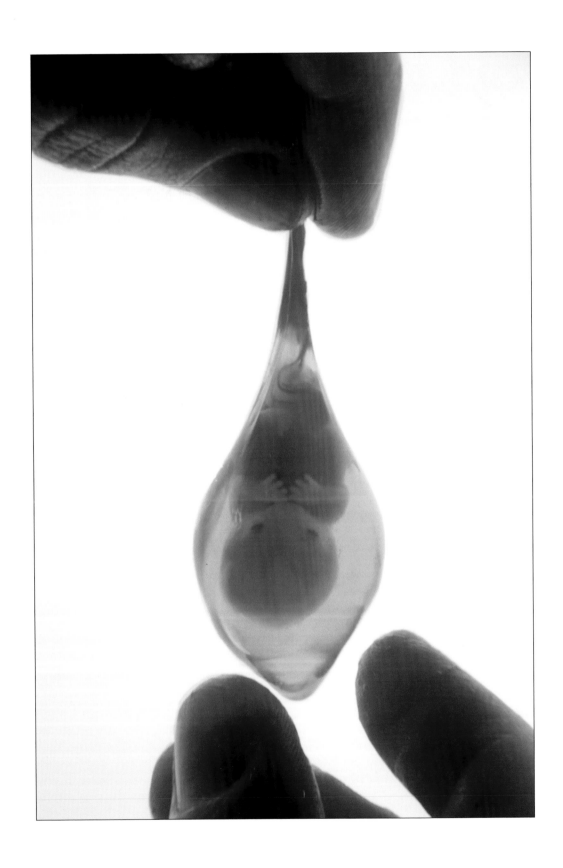

Fetus, approximately eight weeks old, from
an unruptured ectopic pregnancy. 1972.

A Drop of Life in the Sea of Time

One Photographer's Visual Field Notes

A Forty-Year Retrospective

Bob Wolfe

Kokoro Visions Publications

Minneapolis

Published by Kokoro Visions Publications
Minneapolis
bobwolfephoto@hotmail.com
www.bobwolfephoto.com

Design by Dorie McClelland, Spring Book Design
Composed and typeset in Minion Pro, ITC Franklin Gothic, and Gill Sans

ISBN: 9780615387772

First edition.
01 02 03 04 14 13 12 11
Printed in Canada.

This book is dedicated to my family, my friends, and to all those seeking peace along life's fragile yet exciting path.

Contents

Acknowledgments vii

Introduction ix

———

Poof 3

Time 7

Measurements of Time 11

About Photography 13

Speaking to Art 15

Vision 22

Nature, Time, and Space 29

The Early Days 33

How, Who, What, Why 41

Duluth of My Youth 45

Parents 49

Pets, Life, Death, Loss 59

The Music Makers 63

Martial Arts 67

Children's Books 73

Biomedical Photography 77

New Horizons 89

The Human Factor 95

So, What's Normal? What's Real? 105

In Retrospect 109

———

Photo Index 119

Selected Bibliography 123

Acknowledgments

To my wife Diane—for years of love, friendship, support, and sharing, helping to make my life feel truly lived.

A big blanket thank you to all of my family and friends.

Special thanks to my brother Ben for his inspiration in helping humanity through his work as a grief counselor.

To my late parents, who taught by example positive and honest values along with the true meaning of caring, sharing, and love.

To John and Jim Linhoff and my coworkers and friends at Linhoff Photo and Digital Imaging Lab, with a special thanks to Denise Gerke, who has been so helpful over the years with many of my projects.

To Harry Lerner of Lerner Publications and Mark Lerner of Oliver Press for many years of friendship and great book projects.

To Mr. N. Gosei Yamaguchi with respect and appreciation for the sharing of his lifelong dedication to Karate-Do, and to all my many friends in the martial arts with whom I have had the pleasure of training.

To Howard Christopherson and Dea of the IceBox Gallery and Framing Studio for their friendship and beautiful custom frame work.

To Michael O'Neal for his suggestions and help in editing the text of this book.

To Dorie McClelland, book designer extraordinare, for her fine creative work and collaboration in the design of this book.

To my cousin Mike Winkowski who has shown me what real courage is.

To the memory of Raymond Hendler—artist and professor of art, who helped me to think about art in a whole different way.

To Billy Jaap, Duane, and Dave at Good Carma, who have kept our VW camper van—transporter to excitement and faraway places—humming.

To Minnesota Public Radio for their many years of superb broadcasting of classical music.

To all the special people who I have met who have been influential in directing me toward what I see, how I live, and who I have become, I extend my love and appreciation for strengthening the life force in me. And to all those who I may have had little or no personal contact with but who have influenced me through their art, music, philosophy, writing, positive contributions, and good deeds, I express my deepest respect and gratitude.

For many years I have been jotting down excerpts and quotes that inspire and move me; simply grabbing a piece of paper, napkin or Post It note often without noting the source. Later, slipping that scrap of profound recording into the pages of my journal or tacking it up in my lab. Upon preparing the manuscript of this book, there are a couple of these profound treasures I have included of which I have been unable to retrieve the source, from either my personal library or the internet. To those unfound authors I wish to extend my sincere gratitude, to the spirit of their wisdom, vision, philosophy and gifts.

And finally, to all those whom I have had the honor and privilege of photographing over the years, I extend a heartfelt thank you.

Introduction

Most of my adult life has been dedicated to photography and the creation of images. After many years in the field, I decided to prepare a photo exhibit of images from the variety of areas in which I have worked professionally, as well as from other areas that I have been passionate about. This book was written to accompany the exhibit. I have found it to be a most difficult and at times overwhelming task: attempting to share a lifetime of photography in a small book of personal essays, notes, reflections, and selected images. What follows is my humble attempt at that venture.

Photographic images should speak for themselves. Still, I feel there may be some value in offering snippets of my background and history—some of the unique circumstances and personal experiences that accompanied these photographic events. Reflecting on these experiences has certainly been influential in helping me to present the feeling and vision I have treasured and wish to share.

This book is my simple attempt to relate the diversity, struggles, zest, fullness, and joy of life, as well as to foster an awareness of time. Aspects of this include exploring things that have an impact on developing a sense of fulfillment in life; observing the delicate yet resilient nature of our specie, including our quest for uniqueness and individuality; being a witness to the space we occupy; noticing who and what influences us, as well as who and what we influence. Ultimately, this is a book about living: sharing a small taste of my passions and my voyage, carried out in my work as a photographer.

In recent years I have seen many wonderful images created with new techniques and technologies such as Photoshop. These technologies are really quite remarkable and represent a new era in photography. The many possibilities that arise through the manipulation of photographic images has, I feel, a respectable place in this ever-changing world. But personally, being from the old school, I have been more intrigued with trying to present life as I see it happening before me. Rather than adding, deleting, or juxtaposing elements and objects after the photograph has been taken (other than possible dodging, burning, and cropping during printing), it has been one of my primary objectives to capture the critical elements of an image at the time of the exposure. But who knows? Maybe one day I'll change and adopt this new technology as well. Time will tell.

The image on page 2 which I call "The Poof Ball," along with my accompanying description, is an attempt to create a simple metaphor about life itself. Beginning at birth, we enter this world with a perfectly clean slate. Then, through exposure to human and environmental determinants, this perfection is transformed, and our being becomes interspersed with the ideas, philosophies, laws, old wives' tales, and perspectives of others, especially those closest to us. Every person's life takes many twists and turns: physically, emotionally, romantically, financially, environmentally, spiritually. And advancing through this unique life of ours leads to many discoveries: beauty, friendship, love, fragility, tragedy, disappointment, adaptability, and the power, in many cases, to endure and discover meaning through complications and adversity. All of these elements together become our own personal adventure. My photographic experiences represent the path one man has traveled. To all who view and read these pages, I wish peace, happiness, and fulfillment upon your life's adventure.

Each one of us is but a drop of life in the sea of time.

So grab the gusto!
Reach out and embrace life with a sense of meaning—
love, laugh, cry, feel, share, *be.*

Live Life!

~

Bob Wolfe

Oh so perfect, and yet, but a puff of air or the brush from a scurrying rabbit,
instantaneously disrupts that perfection of a whole,
creating a barrage of delicate projectiles
set adrift onto a new adventure . . .

Poof!

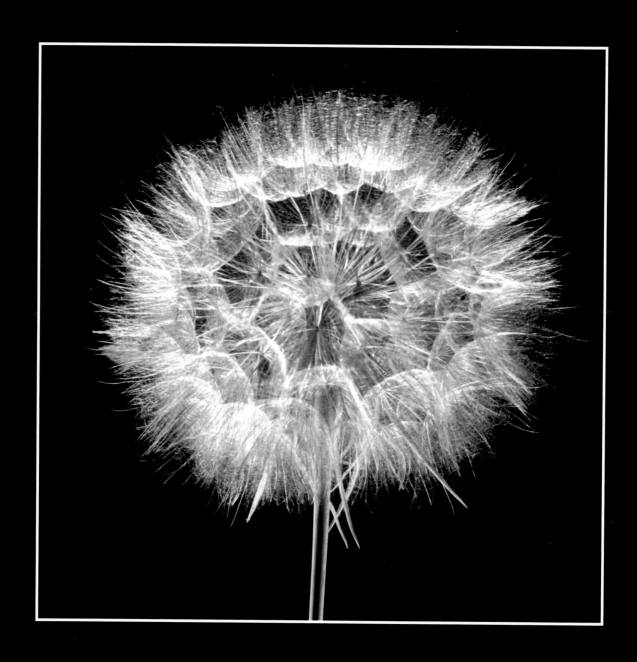

POOF!

. . . Glimpses of Life as I Have Seen It

I consider myself to be an active participant in this life, riding the ups and downs of its experiences, but I also try to be a keen observer. I do this photographically, by recording some of the unique and ordinary vignettes of life I see happening around me.

There are times I see things that spark my interest, instantly fueling my imagination. There are some things that just grab me. It might be an idea or something that stimulates me visually. In that instant my mind starts churning, the endorphins start firing, my pen starts writing, or my shutter starts clicking. POOF! Right brain engaged, I then proceed to personalize that experience.

My photographic work parallels the life I have lived, allowing me to recall stories, people, and places from the past. When looking at ordinary, or what appears to be ordinary, life through my photographs, then reflecting deeply on those individual moments, proves to me that the ordinary can be truly extraordinary.

The moments recorded in my photographs trace the passage of time, but they also testify to time's importance. As a concept, time has already been deeply and eloquently expressed through philosophies, personal ideas, and scientific explanations. But time becomes much more personal when we consider how, where, when, and with whom we choose to spend it and live it.

We spend such a short period of time on Mother Earth, this small but incredible planet. Our window of physical existence in this paradise, this Garden of Eden, is mostly taken for granted. We must truly love it and learn to appreciate it. Our goal must be to live as fully and as humanly as we can. Reach out and embrace the essence of life. . . . Do it!

1. Poof Ball (color). 1973.

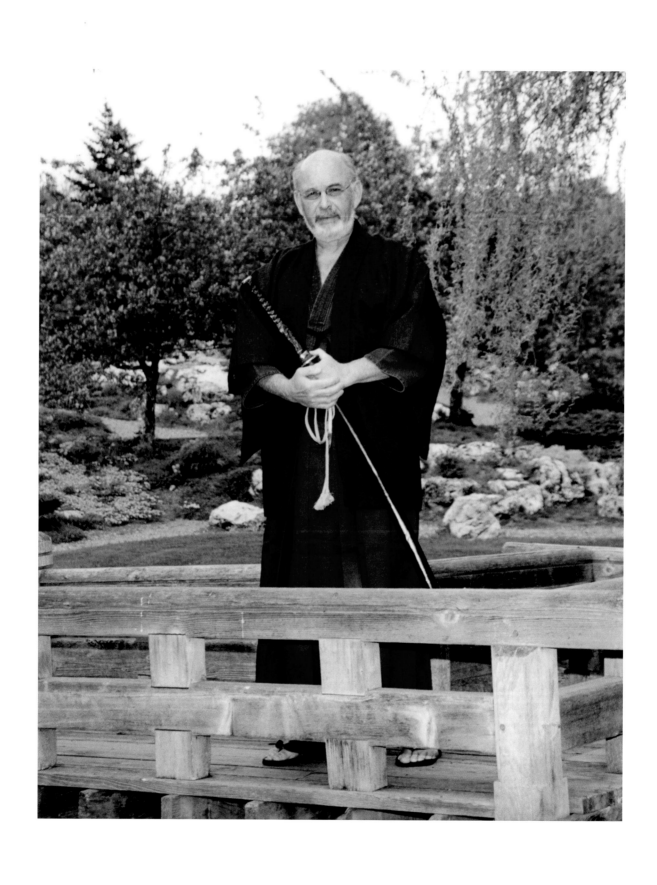

2. Bob Wolfe.
Photo: Michael C. Wong, Minneapolis

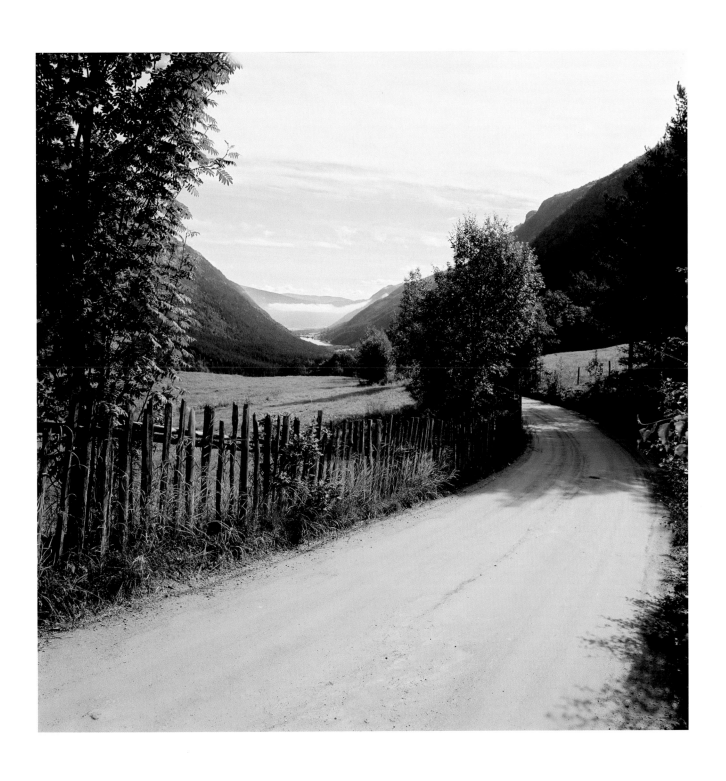

3. Norway, 2001.

Time

Carpe Diem: a Latin saying meaning "seize the day." A perspective shared by those of us who do photography, and specifically for us, refers to seizing the *moment*— in most situations, a split fraction of a second.

In many cases an experience—the feeling, the emotion, the passion—may last only an instant and then it's gone, perhaps forever. A photograph can, to a certain extent, preserve a portion of that moment by jogging the memory.

A person never really remembers, in terms of its fullness or intensity, events such as the pain of surgery or a broken limb. The exhilaration of finishing one's first marathon; driving a motorcycle at over a hundred miles an hour; skydiving; the ecstasy at the climax of lovemaking as its waves crash over your being; the experience of childbirth. . . . These are but a few of the intense feelings one may experience physically.

A photograph of such a physical experience—or of a primarily visual experience—will not only serve as a vehicle to reflect upon past moments, but also as a means to share those moments.

Time . . . constantly moving; tick, tick, ticking away. We assume that there will be a future for us, but we can't rely on that assumption, and that is why it is so important to live every moment. It is good to plan for the future, but it is so important to live in the present. Eugene Herrigel, author of the classic *Zen In the Art of Archery*, wrote in regard to the Method of Zen, "the exponent lives wholly in the present, in the here and now. Not in yesterday, not in tomorrow, and yet in them too, since they are the framework of human existence, of the flux of time." Ram Das sums it up in three little words: "Be Here Now."

4. Joel. To Fly, Caught in Time. 1970.

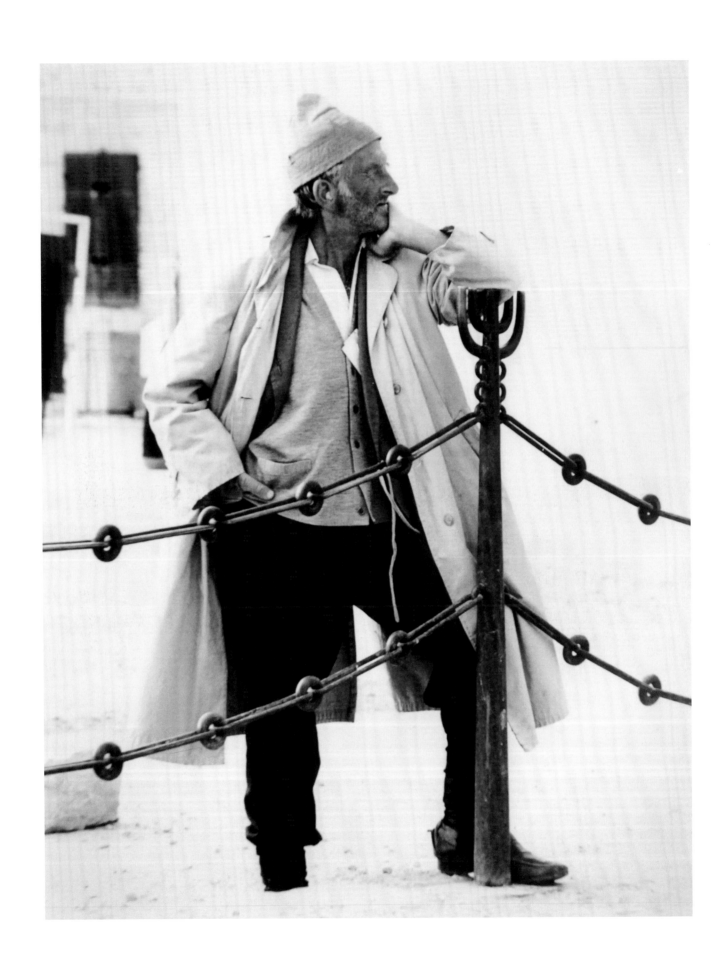

5. Pensive Man. Jerusalem, 1967.

Who has not paused at one time or another, to take a moment and ponder their fate and possibly their existence itself? Questioning: Will I grow old? Will love, happiness, fulfillment and peace of mind play a role in my destiny? It is only time which can reveal the answer . . .

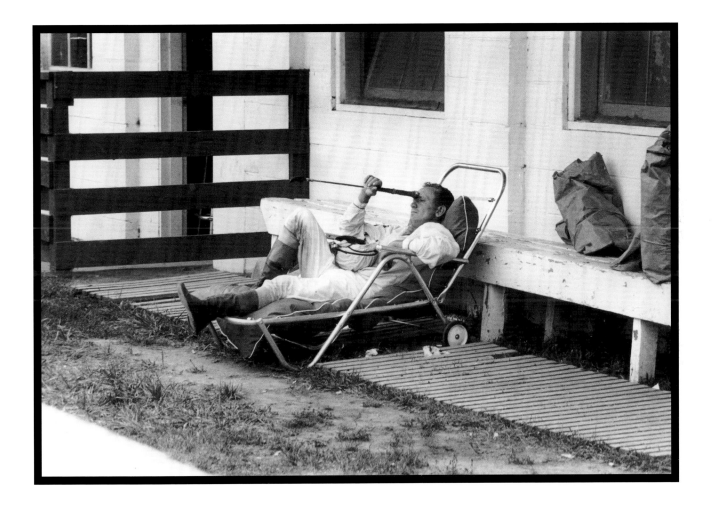

6. Jockey. South Dakota, 1968.

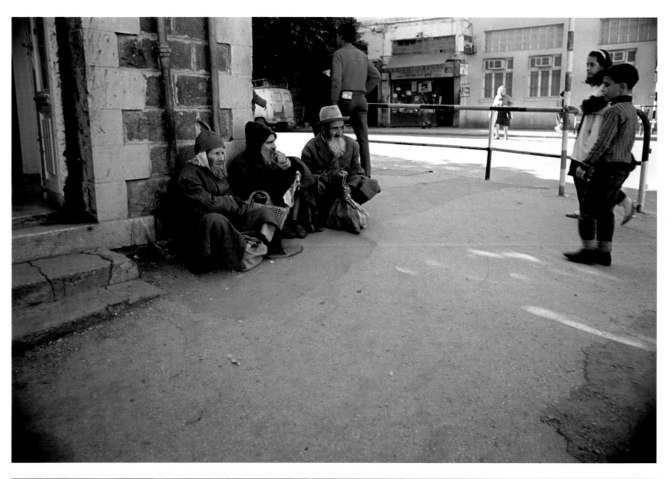

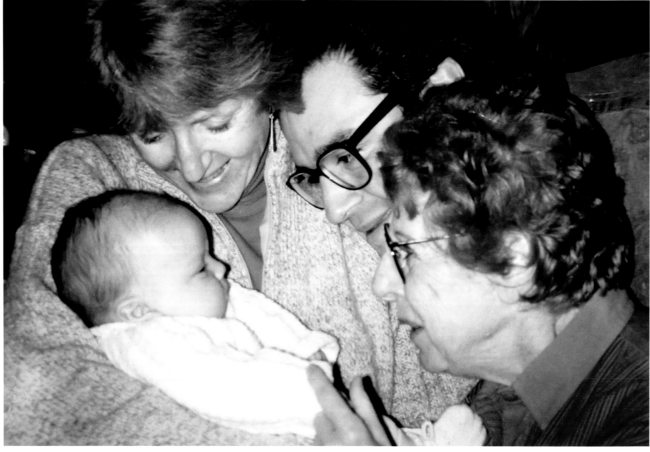

Measurements of Time

"Life, so they say, is but a dream, and they let it slip away."
—Seals and Crofts

. . . Increments, rhythms, and cycles of life defining the human condition . . .

We have all reflected in many ways upon the inevitable and too speedy passage of time. We hold memories of the good times and the bad, of the times we have been happy or sad.

When children are young we may use a doorframe to mark off their growth in inches. From time to time, we think back on their births, or the deaths of others. We think of the experiences we had in school, scouts, sports, the military, or the arts. Of the confirmations, the graduations, the weddings, and the divorces. The vacations and the holidays. Training a new puppy, and, years later, the emotional responsibility of putting it down. The excitement of a new job and the promotions, or the difficulty of having to deal with layoffs, depression, and recovery. The list goes on.

Babies are born and before you know it—POOF! They're smashing up your car, running off to college or to war, and having babies of their own.

Hurdling through time and space: Here we come! Here we are! Here we go!

"And life goes on, with us and without us."
—George Harrison

7. And the Curious Children Stop and Stare, Old Men and Children. Israel, 1967.

8. Gazing with Love and Joy upon the Fourth Generation. 2002.

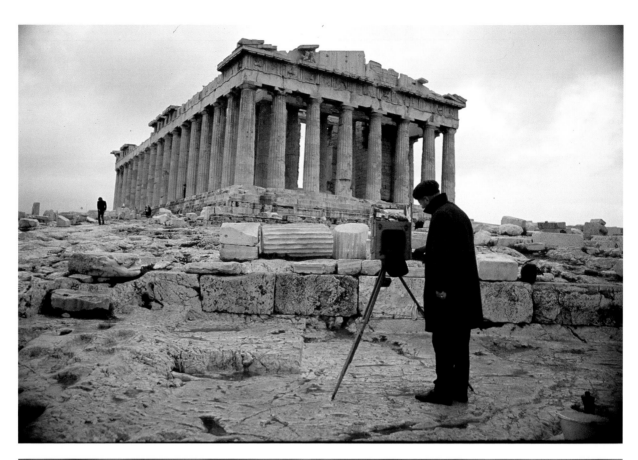

About Photography

I feel that photography has the capacity to enhance, enrich, and remind the photographer about life and life experiences. Photography is not only a way to see and record the world; it is also a means to reflect on life and oneself more clearly. On a transcendental level, photography can serve as a conduit to one's depths: stimulating creativity, enriching the soul, and, possibly, even act as a pathway to spiritual growth and fulfillment. In addition, it offers the photographer a creative medium in which to explore and express his or her unique inner visualizations, true feelings, and hidden fantasies.

For the serious photographer, photography is not merely about what one sees with the eyes; it is also about conveying to others that which is felt in the heart and mind. The Japanese have a term, *kokoro*, that denotes both heart and mind. It does not refer to that magnificent little pump in our chest but rather the spiritual core, our soul. It is the *kokoro*, not the tools of the photographer, that brings the photograph to life and transmits its spirit to the viewer. In this way, photography becomes a way to communicate from heart to heart.

The photographer's challenge is to create images that are a gift to the eye and a provocation for thoughts and emotions. With this in mind, I strive to make images as skillfully as possible, to the best of my ability, hoping to create these images of life, in the spirit of art.

I feel it is not only important to capture and record a unique time, place, mood, or vision, but that it is also essential to share these images with others. It is this sharing which makes the images whole, thus completing the circle of that experience.

9. Athens, Greece, 1971.

10. Photographer. Donnybrooke Raceway,
Brainerd, Minnesota, 1969.

Speaking to Art

"Art is the most profound, most irrepressible response to life itself."
—Frederick Franck

It was the mid-1960s when I told my parents how photography had captured and embraced me, and that this was the career I planned to pursue. Recognizing my serious interest and enthusiasm, they gave me a book that reaffirmed that desire as well as the way I saw people and life. It was *The Family of Man*, a book based on an exhibit created by Edward Steichen for the Museum of Modern Art in New York. It was an eye-opening and inspiring piece of work that determined my major motivation and direction in photography: to observe, be a part of, and, as artistically as possible, record life. I feel that I have been most influenced and inspired by the storytellers, photo-essayists, and photojournalists who contributed to that project, including Henri Cartie-Bresson and Raymond Depardon.

In my youth I had trouble reading, so I gravitated to picture books, comics, *National Geographic* magazines, and the like. Those photos and illustrations, like the ones Norman Rockwell painted for *Post* magazine, had their own personal stories. I could even imagine an extended meaning from such images, putting my own interpretation on someone else's images. Later, when I began making my own stories with photographs, I tried to reflect on those early memories of picture books and storytelling. I thought about the skill, imagination, and especially the artistic effort required to tell a story from what was often a single image.

Photography has been my vocation for many years. It has been a means to financially support my family. Depending on the economy, slumps, and other bumps in the road, this wasn't always easy to do. I was forced to search out more or less commercial ways to do photography. I sought commercial work in a wide variety of areas, but I always kept the art aspect deeply entrenched within me.

I have always admired those artists, guided by their heart, who have devoted their whole being to producing their art and who must have been forced to make serious sacrifices. Well, I guess we all make choices. At times, certain situations or opportunities become influential in turning us in a different direction or onto a different path. Sometimes it is very difficult, as Joseph Campbell would say, to "follow your bliss." Although a certain amount of luck may enter the equation, I believe the most crucial aspects in the pursuit of art and life itself involve hard work, patience, a positive attitude, and perseverance. It's so important to do what you've got to do and just do it. And keep those ideas and dreams alive.

11. Raymond Hendler, New York School Abstract Expressionist, action painter and pioneer of modern art. 1979.

Often I try to look at myself in terms of my artistic accomplishments and my ability to think and create in the spirit of art. I have always strived toward the goal of artistic merit, however many times I feel I end up short of the mark. I try to see, feel, and work as an artist, trying to make my work speak to art, but sometimes the results aren't there. It is then that I must remind myself that all efforts towards art do not make art. Both those efforts that succeed and those that fail help you to grow and hopefully become a better artist.

However, there are also times when I experience the feelings, the vision, the drive, and the excitement that I had in school. As students we debated and shared philosophies pertaining to art, asking what art really is about and who makes it. Is it real? Is the expression delivered in an honest fashion? Is it new and original, or is it strictly novelty, or perhaps just something to inflate the ego? Am I, as an artist, representing what I have felt or witnessed to the best of my ability, both grammatically and visually speaking? Is my work from the heart?

As has been proven by so many things in life, nothing is really perfect. But with a lot of diligent practice and hard work, some things come very close. In the study of karate, for example, there are forms called *kata* that illustrate the endless path to physical and mental perfection. During kata, which seems to resemble dance or ballet, the practitioner does battle with imaginary opponents who attack him from different directions. There is blocking, striking, and kicking, along with different stances, breathing patterns, and movements, all of which require certain paces and rhythms. The forms are practiced over and over and over. There is a saying that after practicing your kata ten thousand times you may have demonstrated the perfect performance, yet never have performed the perfect kata. The saying is meant to remind the practitioner that there is always room for improvement, no matter how well others think we perform or how well we think we perform. This lesson is applicable to all aspects of life, including art. No matter how old we are, there will always be more secrets to uncover and discover in one's attempt toward this illusive concept of artistic perfection.

"The essence of the martial arts is not the strength, not the art, but that which is hidden deep within yourself . . ."

—Master Gogen Yamaguchi

12. Nicholas Harper, artist and owner, Rogue Buddha Gallery. Minneapolis, 2006.

16

13. Big Bug. 1989.

14. Pensive Lady.
High-contrast flip-flop Kodalith negative from original
35mm B&W negative. 1974.

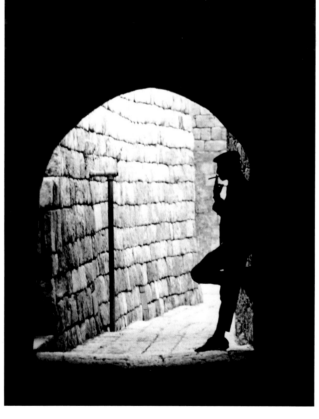

15. Alex and Elliot. Minnesota Renaissance Festival, 1999.

16. Diane, 1972.

17. Smoke Break.
Jaffa, Israel, 1967.

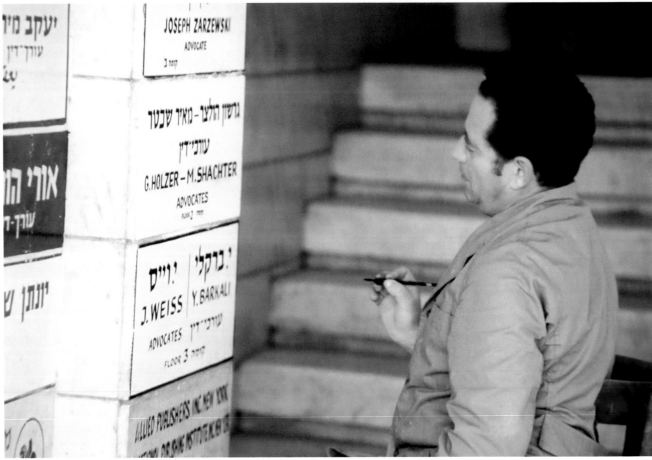

18. West Bank. Minneapolis, 1972.

19. Sign Artist. Israel, 1967.

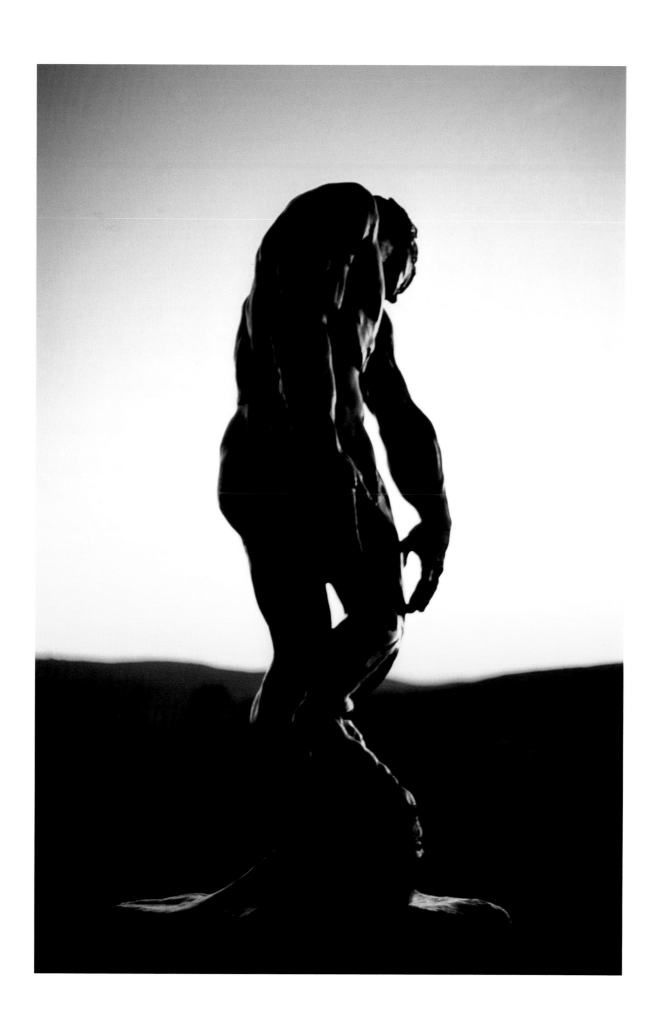

20. Adam at Sunset. Auguste Rodin's "Adam."
Billiy Rose Sculpture Garden, Jerusalem, 1970.

Vision

We can see and visually experience so much. Do we really see? For it is more than that which is before us. Not just looking, but seeing; one must look deeply, feel deeply. Carlos Castenada referred to "seeing" as preceiving the "essense" of things of the world.

There have been times when I have come upon a scene that is so beautiful, breathtaking, awesome, and inspiring, I might describe it as visually intoxicating. It seems to be one of those spiritual experiences we all want to be a witness to: observing and being consumed by the lighting, the stillness or the movement, or the incredible subject matter. How it all works together, seemingly so natural, so profound, and so perfect, giving one the feeling of something more. Perhaps it is that rapture of not just looking at but truly seeing and living life. Some examples:

—On an early-morning drive through Norway's Lofoton Islands north of the Artic Circle, after going around a bend in the road, we came upon an amazingly beautiful and tranquil view: a quiet fishing village nestled beneath an incredible rock formation. The scene was literally breathtaking.

—In Alaska we drove thirty miles up a rough, narrow gravel road to a mountain's summit, with its small abandoned miners' cabin and its majestic view of a glacier and surrounding peaks, all changing moment to moment from mist to periods of brilliant sunbursts.

—As we hiked toward the ruins of an ancient Colorado Anasazi Indian cliff dwelling, we were treated to the way the afternoon light illuminated this awesome site.

—In Israel, climbing the serpentine trail of Massada in the Negav dessert overlooking the Dead Sea, I remember the exact time and date of that image: high noon, January 2, 1971. My wife and I were halfway up our assent and stopped to take a drink from our canteens. We heard a noise and, looking up, saw a bucket suspended on a cable descending. Men constructing the new air tram were heading down for lunch.

There are some images that one has the time to view and study, setting up for the best angle, or the time of day for the best light. But then there are those such as Massada, which one must respond to immediately: reflexively bring up the camera and make the exposure—just now—Boom! That kind of image is a one-chance encounter which, if not made at that precise time, cannot be duplicated and is therefore lost. The capturing of such a unique time, place, or vision is a dimension of photography that adds to the excitement and fulfillment of being a photographer.

21. View of the Dead Sea and Negav Desert, as seen from the serpentine trail on Massada (workers erecting air tram descending for lunch break). Israel, 1971.

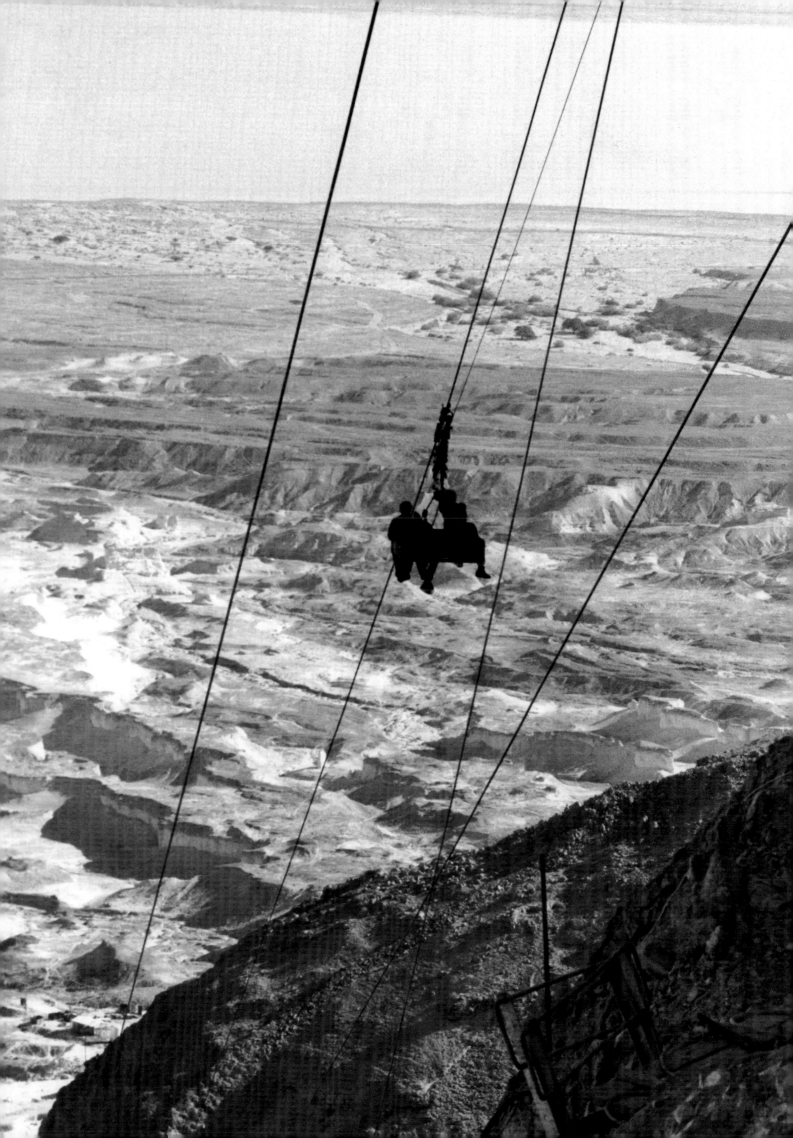

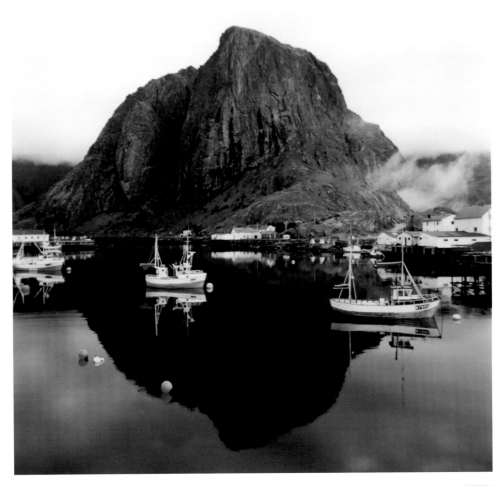

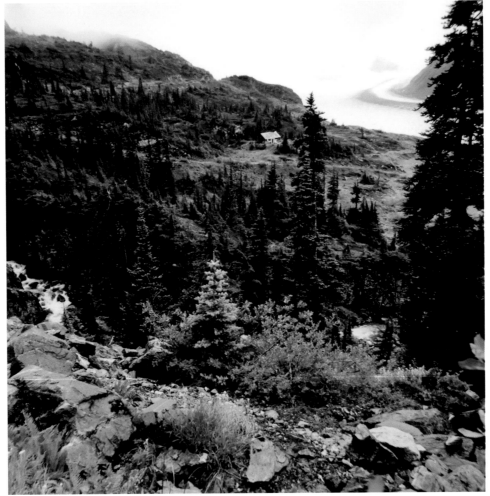

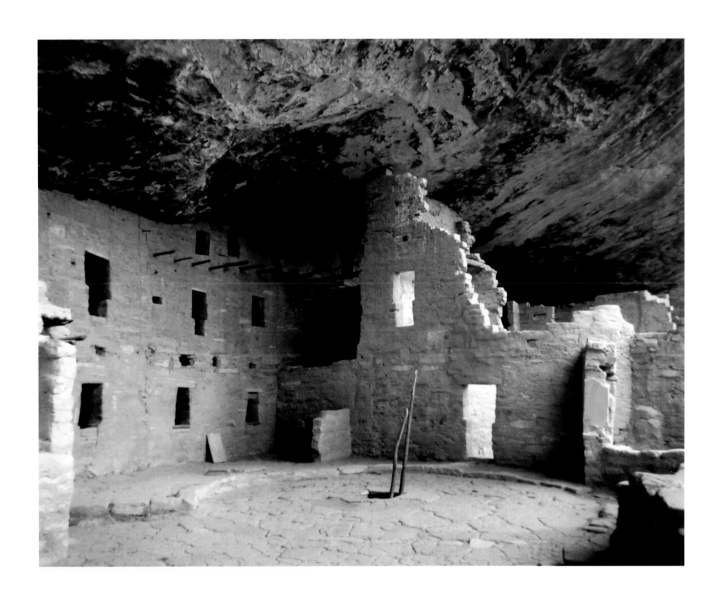

22. Homnoy, Norway (Lofoton Islands), 2001.

23. Room with a View. Salmon Glacier, Hyder, Alaska, 1995.

24. Anasazi Cliff Dwelling. Messa Verde, Colorado, 1988.

At special times in the past, when these phenomena revealed themselves to me, I have reflected upon a Seals and Crofts song where they sing, "We may never pass this way again." Or, in a more esoteric sense, I thought of Thomas Wolfe saying, "You can't go home again." Just as people change in so many ways, the same reality is true of landscapes. For any number of reasons, the possibility to return and relive an adventure or special experience may not be possible: it is a one-time encounter. Of course, it would be ludicrous to say that the photograph taken of such an awesome vision has captured one hundred percent of the scene's true essence. Rather, the photograph represents the photographer's attempt to *imitate* the reality he experienced. The photograph is merely a reminder of the sight, sound, smell, and feel of the real experience, as well as a reflection on the history and the people who inhabited these places. Looking back at the photographic images I made of such special times and places, I find that my pictures give me, to a certain degree, that flash of life's treasure once again.

The reality of life is that it is not all beautiful, not always filled with happiness, love, peace, wine and roses. I have also been witness to scenes that have been so heart wrenching, tragic, and horrible that they have left an indelible mark on me. These experiences, painful as they were, have made me thankful in so many ways, especially with regard to such things as my health, peace, opportunities, and freedom.

In a lighter vein, there have also been those unforgettable times when an incredible shot was there but impossible to take. I don't think I will ever forget the experience of sliding down an icy Colorado mountain road in the middle of a huge, almost whiteout snowstorm, trying desperately to keep our little VW bug under control, and not smash into another vehicle or careen off the mountain. Then, a quick glance to our left revealed a flock of sheep, standing out in the blinding snowfall, on the side of the hill, all looking in our direction. All you could really see were their black eyes and black noses. "The sheep in the snow storm." There was no photograph taken, but what an incredible visual image, experienced in such a short and frantic glimpse of time! That image has been indelibly imprinted on my memory, along with so many of the scenes, special times, and experiences I was able to photograph.

25. Eiffel Tower. Paris, 1975.

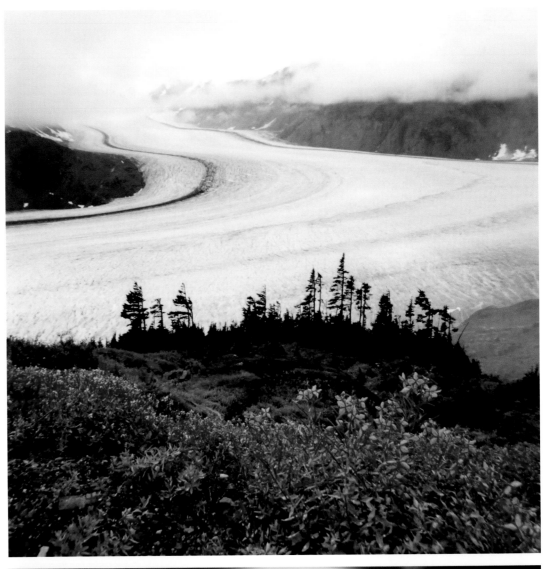

28

Nature, Time, and Space

"Now and again, it is necessary to seclude yourself among deep mountains and hidden valleys to restore your link to the source of life."
—Morihei Ueshiba

The awesomeness of nature that surrounds us so often goes unnoticed by so many of us as we go about our daily routines, absorbed in and often consumed by them.

It is so important to take time to be in nature, observing the real world as it lives, breathes, and changes: from the small microcosmic community found in a square foot of forest moss, to the miles of a living, moving glacier. Here, the slow and imperceptible movement of that huge mass is scraping away enormous rocks beneath it which will ultimately become one with the glacier. This migration is only visually comprehended by its glacial moraine pattern. That slow movement continues unnoticed until there is an enormous event, such as a huge portion breaking off with an incredibly loud, almost explosive sound. Then this is followed by a great spatial displacement of water beneath, where it comes to become one with its new surroundings. And the cycle continues.

In terms of nature, wildlife, and landscape photography, I have always admired the dedication and marvelous work of such contemporary masters as Ansel Adams, Galen Rowell, Jim Brandenberg, and Art Wolfe, to name a few. They have produced such unique, beautiful, and heartfelt expressions of our natural world through their masterful use of the elements, timing, and knowledge. They are truly inspirational and examples to use to push oneself on, to search out and try to create unique and original work.

I love nature and the outdoors. It dates way back to my youth in Duluth, Minnesota, and my involvement in the Boy Scouts. I love to photograph nature, but I don't consider myself a nature photographer as such. I have derived much pleasure from observing and trying to capture and recreate what I have seen and the mood I have felt in these special places and spaces. With many of these images made in nature, I feel I have been exposed to the reality of sacred place. It also reminds me that, actually, anywhere can be sacred, as everything and everywhere is considered to contain at least a trace of the divine. This world of nature, along with one's observation, participation, discoveries, and respect for it, can help bring us closer to the core of our soul.

Henry David Thoreau loved just sitting quietly, observing and listening to the birds and to all of nature. It seems to be so difficult for most people to do this—just sit quietly for a time, observing and simply existing.

26. Salmon Glacier. Alaska, 1995.

27. Acorns. Patiently lying beneath a beautiful canopy of majestic oaks can be found the seeds or tomorrow's forest. 1971.

Besides the enjoyment of being out trekking through nature, I identify with Thoreau, as I also love to just sit quietly, taking time to observe nature. Much of this quiet observation can take place not only in the wilds but also in urban spaces, as well as one's own back yard. Watching such things as ants, marching around on the petals of a peony flower. A hummingbird or sphinx moth shoving its needle beak into the depths of a ripe flower. A honeybee, busy flying from flower to flower collecting its gold. A tiny chipmunk filling its little cheeks with acorns till it looks like they will burst. The song of the cardinal. The chick-a-dee-dee-dee of the swooping and tough little hooded creature of the sky. The crashing waves of the ocean. The falling fresh spring rain. The gentle sounds of a babbling brook. The aroma of the pines or of the damp earth.

It is not just about visiting nature in the warm comforts of a summer's day. It is also taking in the brilliant fall pallet of reds, yellows, and orange of the maple, aspen, and oaks, as they ever so reluctantly shed their colorful leaves. Then, a big chilly wind, hard rain, or early frost comes and hurries up that magnificent process of seasonal change. Next, the falling of snowflakes, bringing on the blanket of winter's wonderland. Finally, leaving the cold behind arrives the blooming of spring, recreating that vision of life and completing nature's cycle in all of its splendor once again.

It is taking time to be still, to look, to listen, to smell, to feel, and to be.

To be is not the question—it is the answer.

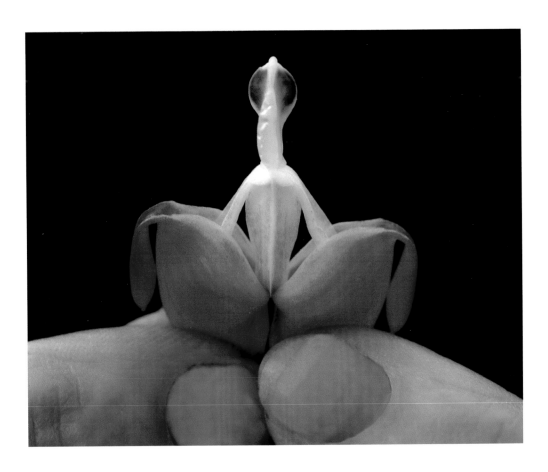

28. Bleeding Heart (Lady in the Bathtub). 2008.

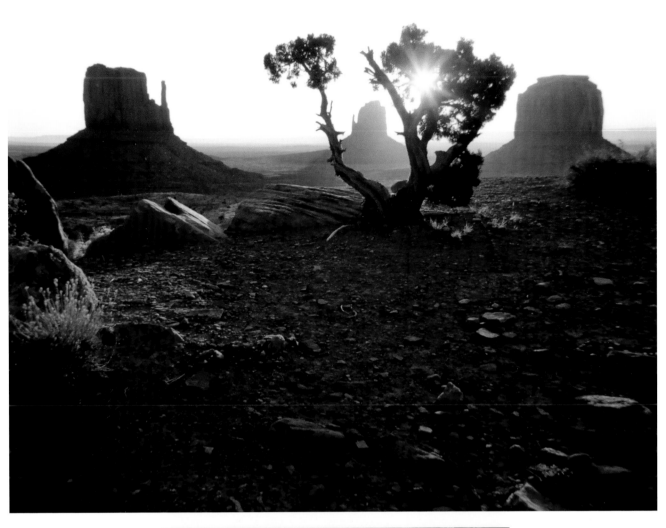

29. Good Morning America, How Are Ya?
Monument Valley, Utah, 1992.

30. Rock Wall. Alaska, 1995.

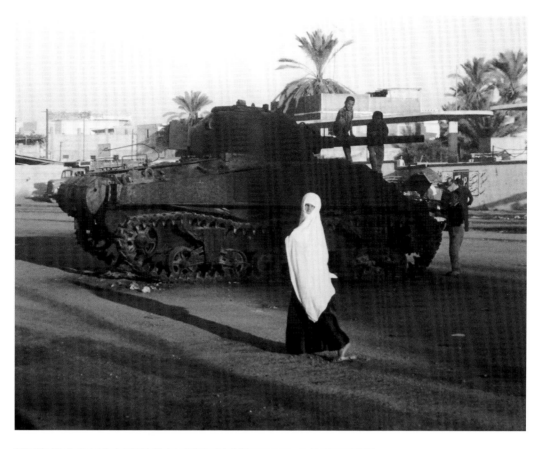

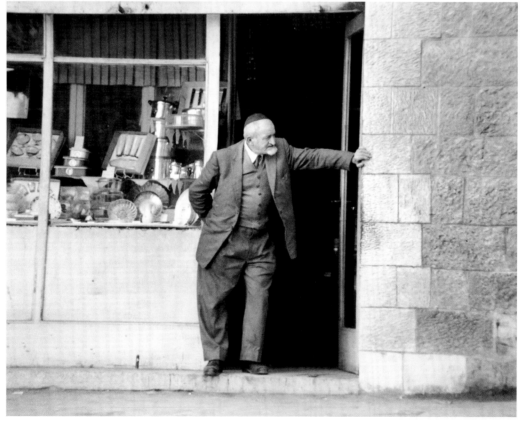

The Early Days

In the context of my early development as a photographer, I felt it was important to begin creating a personal body of work. It was necessary not only to sharpen my tools but also to work toward developing a style. I also felt that a most important aspect of this profession lay not only in the seeing, recording, and compiling of images, but also the striving towards truly feeling, living, and being a part of the experience, even if to capture the image I would be no more than a quiet observer.

Besides the required courses at the university, the ones that really drew my interest in addition to photography included human and cultural geography and anthropology. I also took classes in anatomy and physiology, as for a time I considered a career in physical therapy. This is a very important and I am sure most rewarding profession for the therapist; however, I realized this was not for me. I needed a career that would produce more immediate gratification. Also, as a visual person, I needed to be able to express my feelings in a way such as that which can be found through photography. Ultimately, those science courses would prove to be very beneficial when I later worked in the field of biomedical photography.

In 1967, returning from six months in the Middle East, having photographed life immediately following the Six Day War, I was eager to somehow break into professional photography. I had these secret dreams and fantasies of becoming a world traveling National Geographic or Magnum photographer or something equally as adventurous, romantic, and exciting. I kept checking the want ads for photographer or photo assistant jobs. I came across this ad: "Portrait photographer wanted—willing to travel."

So I began my professional photographic career in 1968, when I took my first paying job in the field as a "kidnapper." That's what they called us back then. It involved taking portraits of children and family groups. It was like being a gypsy photographer, traveling from town to town.

I worked for the Don Marvin portrait studio based in St. Paul, Minnesota, and traveled in my little 1965 VW bug thru Minnesota, North and South Dakota, Nebraska, Iowa, Wisconsin, and Illinois. The studio catered to the small farm towns, and I would be in a different little town almost every day. Being on the road was truly a learning experience in many respects. I was a one-man show. Setting up, shooting, then tearing down. If something broke down or needed repair, I would have to fix it myself.

A "booker" would go out two weeks ahead of me and set up the booking place and time to shoot. He had a drinking problem, and as a result I was booked in some most unusual places including laundromats, dry goods stores, next to the grease rack in a repair garage, next to the pool table in a small bar, and once in a

31. If Nothing Changes, Nothing Changes. Gaza, 1967.

32. Shopkeeper. Israel, 1967.

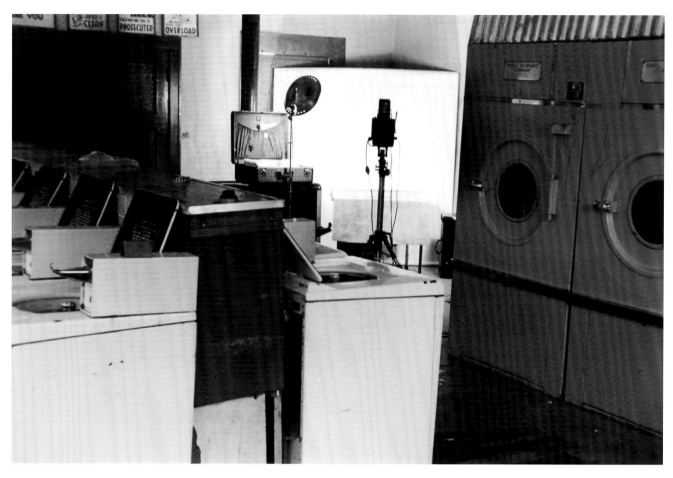

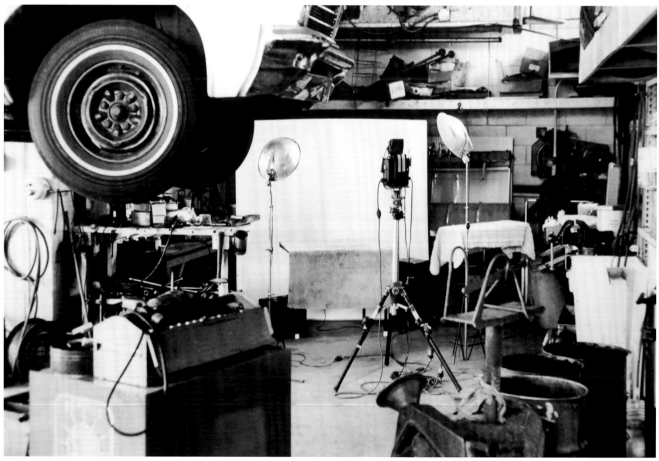

dirty, damp basement of a small-town mortuary. I would photograph children of all ages, family groups, and sometimes animals, carried, leashed, or dragged into my portable makeshift little studio.

I used a 70mm Beatie Portronic camera, three 500-watt floods, and slow black-and-white film. Considering how the children would move and squirm around, I quickly learned the important value of timing. Pose and shoot, pose and shoot— sometimes a hundred sittings or more a day, some days just a few. I would send the film up to St. Paul on a Greyhound bus. The studio would process the film and make 4 x 5 proof prints. Two weeks later, a proof passer would visit that town and make the sales pitch. I made a flat fee from the studio for the month, plus I would get a bonus for everything over so many sittings or over how many sales were made. This experience not only helped me to learn a great deal about portraiture but also about people.

I stayed in small cheap motels and hotels. Sometimes, having driven a long distance from one town to the next or as a result of a full day's shooting, I would pull into the next town quite late. I would explain that I was going to photograph children the next day and needed a place to sleep. Back then, it seemed like every-one was so nice, trusting, and accommodating. One night I came into a town late and slept in a cell in a quiet small-town police station. Another night it was the back of a rescue squad ambulance in a fire station. That particular night's sleep was constantly interrupted by the police-band radio squawking on and off all night. I thought for sure I would have to jump up and get out with the next call.

A few times I had to sleep in my little VW bug. I had taken the back seat out to accommodate all my gear; camera, lights, backdrop, stands, table, hand poser, toys, noisemakers, tools, my clothes, and other stuff, all jammed into the little car. In the old bugs there were no safety headrests. I would rig it up with the tabletop and hand poser across the seats and through the steering wheel, roll out my sleep-ing bag on top, and, with my nose almost touching the rear window and my toes touching the windshield, I would try to get some sleep.

During this period of gypsy-type meandering across the Midwest, there were occasions when I met a few lonely single moms having their child's photo taken. Following some chatting and a little flirting, some would invite me home for din-ner after my day's shooting. This kind and friendly gesture not only saved me the cost of a room for the evening but also provided a respite from the tedium of those months of long, lonely nights. Another little adventure in the life and times of a young, single, and eager-to-learn photographer.

33. Laundromat Studio. South Dakota, 1968.

34. Garage Studio. Nebraska, 1968.

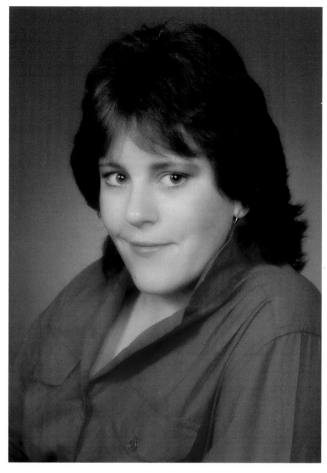

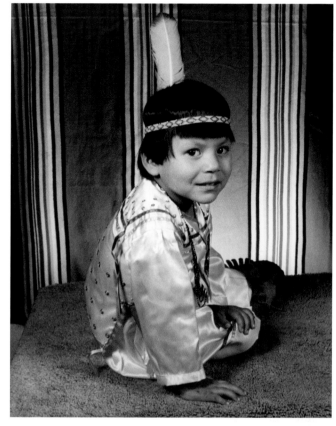

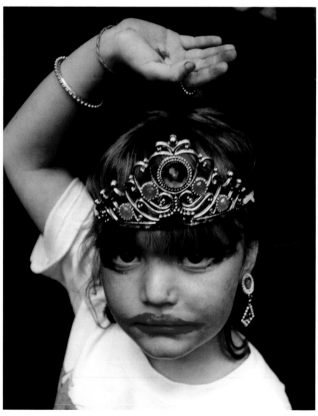

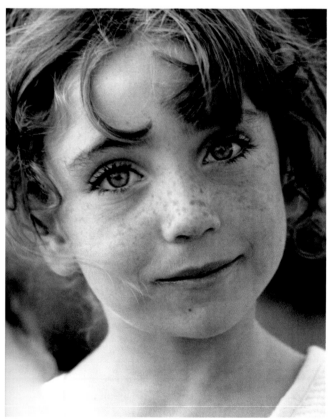

Regarding portraiture, I have marveled at and held in the greatest respect and awe the magnificent portraits of Yousuf Karsh. The lighting, the care given to detail, his timing: waiting to capture that gesture or expression defining those he is photographing. I am moved by his early life of persecution in Armenia and his gift of a free life and opportunity in the New World (Canada). He had a brilliant career of meeting, conversing with, and then, through his photography, depicting and sharing so many famous people of the early and middle twentieth century. A true master in every sense of the word. I feel that his gift of seeing and understanding, his compassion, and his sharing of this gift will remain as a treasure in the history of photography.

When making either formal of informal portraits, I try to see the subject as an interesting and unique human being. The basic elements are *isolate, observe, and express*. I have also tried to practice an approach that an art professor of mine described: "Look beyond the glare of the bulb." It is so easy to make assumptions and judgments about people or situations, especially those you have encountered for the first time.

The popularity of famous people, and the photographing of them, can bring much exposure and notoriety to the photographer. This in essence can be a great boon to one's career. A prime example of this is Karsh's portrait of Winston Churchill taken in the early 1940s. When I look at portraits made by Karsh, Steichen, Avedon, and Leibovitz, for example, I see famous and recognizable people being artfully portrayed. I have had the opportunity to photograph some famous people in the past and it has been very rewarding, but I also very much enjoy photographing everyday people, the common man. The one who is not so visible, romantic, exotic, or important to the public, but nevertheless important as a unique human being. Someone possibly known and appreciated only by family, friends, neighbors, or co-workers: someone my wife's uncle Yok would refer to them as "the salt of the earth."

On a more personal level involving portraiture, my family and friends have always been some of my favorite subjects to photograph. They have been instrumental in helping bring me closer to a rich and full life experience.

35. Joanne at 17. 1981.

36. Little Indian Princess. Nebraska, 1968.

37. Alex—Self-proclaimed Gypsy Princess.
("Yes, I do all of my own makeup.") 2000.

38. Little Girl with a Curl. Israel, 1967.

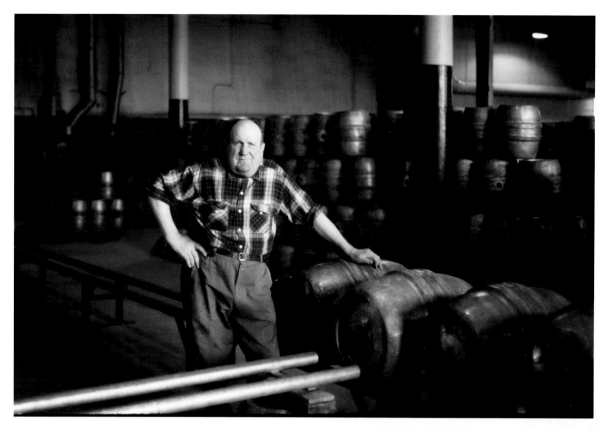

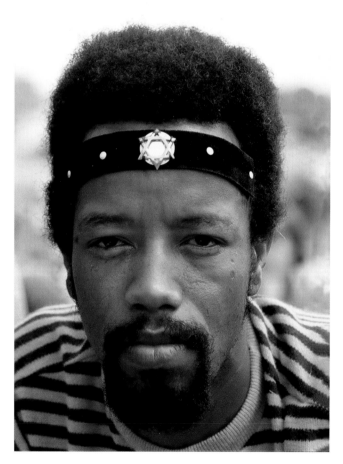

39. Barrel Man. St. Paul, Minnesota, 1967.

40. Unknown Man. Stevens Point, Wisconsin, 1969.

41. Chuck the Hammer. Minneapolis, 1979.

42. Diane. 1972.

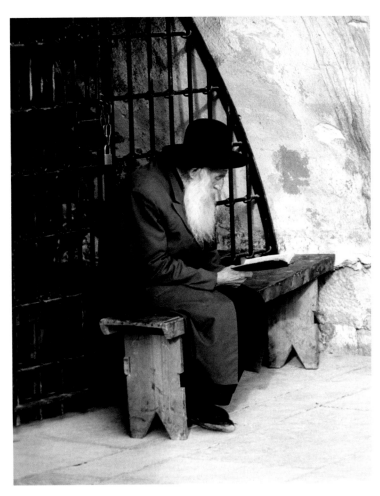

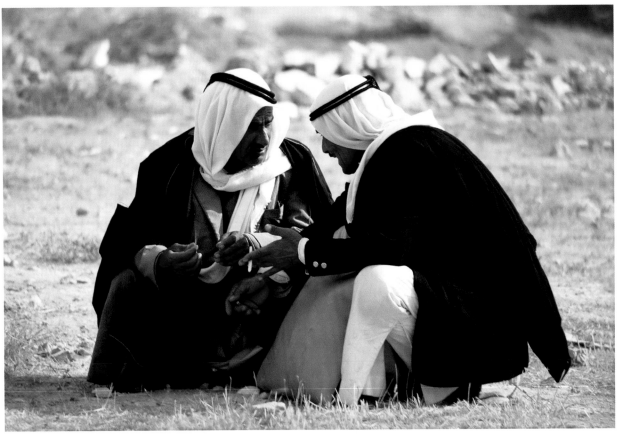

43. By the Wailing Wall. Jerusalem, 1967.

44. Ber-Sheba. Israel, 1975.

How, Who, What, Why

My tendency is to strive to reflect a feeling in my work of a calm, gentle, peaceful, and serene mood. The seven years I worked as a biomedical photographer at the University of Minnesota Health Science Center somewhat directed me more toward telling a story in terms of very accurate representation. It was important as a medical photographer to correctly and clearly depict medical research and procedure, which would be used in teaching and presented in medical books and journals. Accuracy was also required, as the photographic images were used in some cases as a diagnostic tool.

Then there was my commercial work, which usually required a very specific approach as to how the client's subject matter was to be presented. In creating the images it was essential to take into consideration the feeling, acceptance, and marketability of the product or concept. Now, being mostly away from the commercial side of photography, I feel that what or how I shoot doesn't really have to be important to anyone else; it's not something one must put a price tag on. It is the freedom to photograph what I have seen, felt, experienced, and chosen to share. My approach is mostly to allow the experience to reveal itself to me, rather than setting out to capture a specific shot. Certainly in many cases I have gone out with a theme in mind, then gone on from there, striving to capture and relate my personal vision of that drop of life in the sea of time.

I have always tried to be aware of not offending or not participating in an invasion of privacy or overstepping my bounds where someone might be hurt emotionally. There have been times when the shot was there but I chose not to take it for that reason, thinking, in that same situation how would I have felt. I just try to remember the personal experience of that time, place, or situation; like that of the sheep in the snowstorm. Those images I do have the freedom to take are what I feel I must record, to try and capture my interpretation and share the value of that experience, of that time.

I like to think of photography as visually stimulating and entertaining the viewer's imagination: to bring something familiar or new to the viewer. It can be something to identify with, or something to cringe at and be thankful that that particular scenario did not include them. It can also be just fun, light and humorous, even a little mischievous at times, trying to somewhat keep alive that child within. Possibly an altogether new scene, image, or way of looking at something, or a little different angle or twist on an old theme; thought provoking, capturing one's imagination. Trying to bring the viewer's full attention into the scene. Instilling a curiosity, conveying confusion or wonder. Even possible repulsion through the presentation of a graphic, real life tragic event: seen through the eyes of a photojournalist, its intention is not to exploit the event but rather to reveal and inform.

I have seen and photographed many of these life phenomena and find value in them all. However, I prefer to depict the world more calmly, with a more serene

feeling. My intention is not to be like an ostrich with its head buried in the sand, only seeing what I want to see, but rather to hopefully stimulate a more peaceful mood; one such as that created by classical music, as opposed to the violence and anger commonly found in some rap music, or seen in violent video games. They all have some value and tell a story; however, they can also produce a very negative and disturbing influence on our energy and our being.

This world we live in can be a violent one, and, unfortunately, human nature has the ability to display a morbid and violent curiosity at times. Through my photographs I like to share mostly the nonviolent and peaceful things we can experience in this life. It is in opposition to the constant bombardment of those TV shows and movies depicting rape and murder that can't be very productive for a world in search of peace. It makes me look at my world and think back to what I felt was a most profound saying a pal of mine, Don Hilson, said to me way back when we were still in high school: "And what has happened to us altogether?"

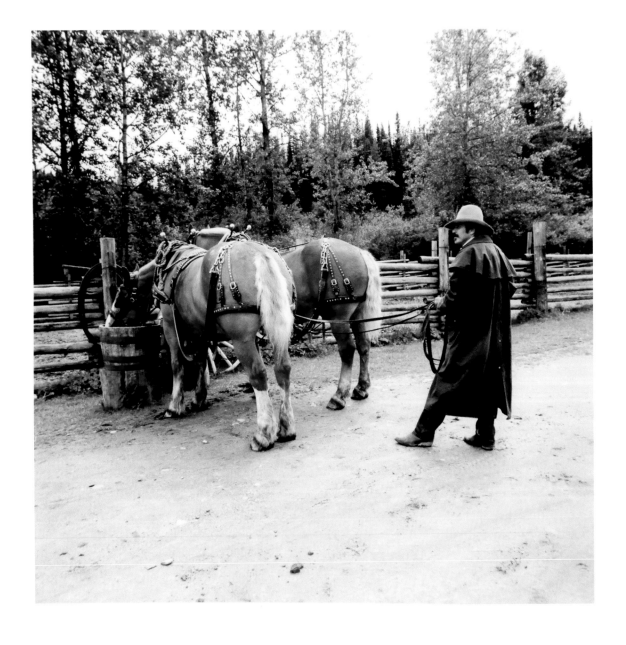

45. Cowboy with Team. ("Take a big drink, boys.")
British Columbia, Canada, 1995.

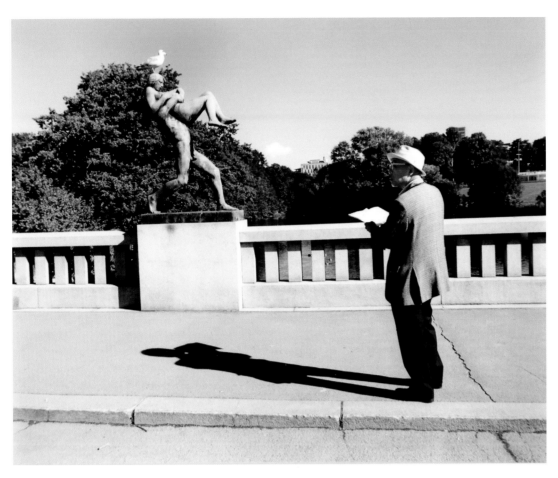

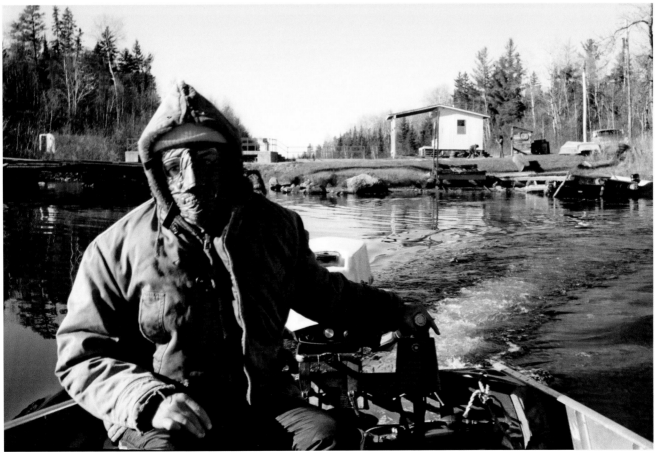

46. On the Bridge. Oslo, Norway, 2001.

47. Emo, The Fish Wrestler. Ontario, Canada, 1978.

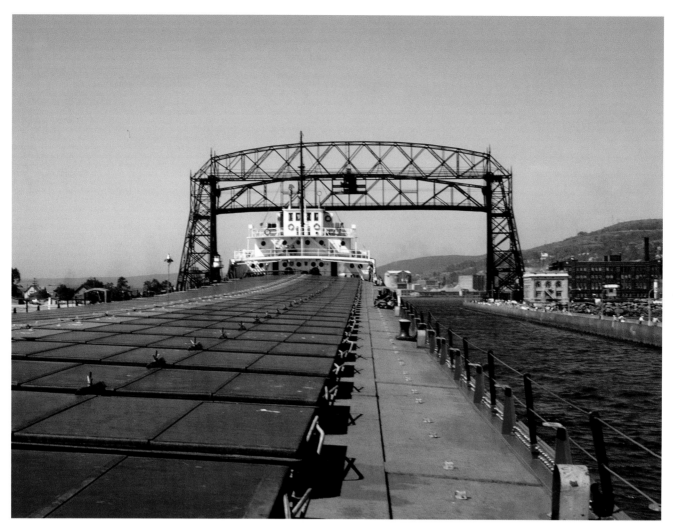

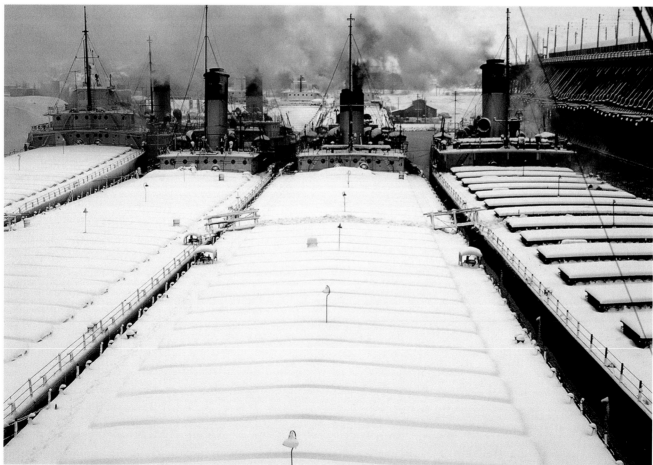

Duluth

"The Boats"—that's what we called them, and by living in such close proximity to Lake Superior, many young men from Duluth would find work on them. They would sail to make money for school, cars, adventure, and the like. Growing up in Duluth I would see that big lake every day, from my home, my car, walking, or from my school window, daydreaming—looking out over that great body of water. So I decided to sign up and ship out for a season. I don't have a large number of images from this period, but those I do have are quite meaningful with regard to my early years.

My vessel was the United States Steel Corporation's ore carrier *D.M. Clemson*. It was one of the last coal-fired ships driven by a huge triple-expansion steam engine. It was approximately six hundred feet long and fifty feet wide, and designed to slice through and go over the type of waves found on the Great Lakes. If she were to go into the swells of the ocean she would break up in no time. You could actually see her bend and bow during big storms. It reminded me of the flexibility of those very tall skyscrapers that, they say, actually swing back and forth a bit in a big wind.

We loaded up with iron ore in Duluth, Two Harbors, Silver Bay, or Superior, then steamed down to the lower lakes through the Sioux Locks. Our destination was mostly the steel mills of South Chicago, Gary, Indiana, and Conneaut, Ohio. On some occasions we would carry coal back from Toledo, Ohio. Mostly we sailed back up to Duluth, carrying a hold filled with water as ballast, which produced a lower, smoother, and faster ride.

My official title was "Wiper, Coal Passer," and I spent most of my working hours in the engine room. There were three shifts and we would work four hours on and then eight hours off, four on, eight off. My shift was from 4 a.m. to 8 a.m. and 4 p.m. to 8 p.m. There usually was some sort of little adventure happening, either aboard ship, while crashing through the early season's layer of ice, or being launched up and down during a great storm in which waves could reach fifteen feet in height, or the few hours we had on shore during loading and unloading, if it wasn't on your watch.

I fitted the boat out in April, and after nine months and twenty-seven trips up and down the lakes without a day off, the first thing I did after laying the ship up for the winter was to take some of that hard-earned money and buy myself a brand new 1965 Bahama-blue VW bug. It cost $1,875—a dollar a pound back then. It was my first and, to date, my only new car.

Duluth of my youth. It was a great place to grow up in as a kid. It still holds many fond memories of early life, friends, and youthful adventures.

48. *D.M. Clemson* Preparing to Enter the Duluth Harbor under the Aerial Lift Bridge. 1965.

49. *D.M Clemson* Nestled in for the Winter. 1965.

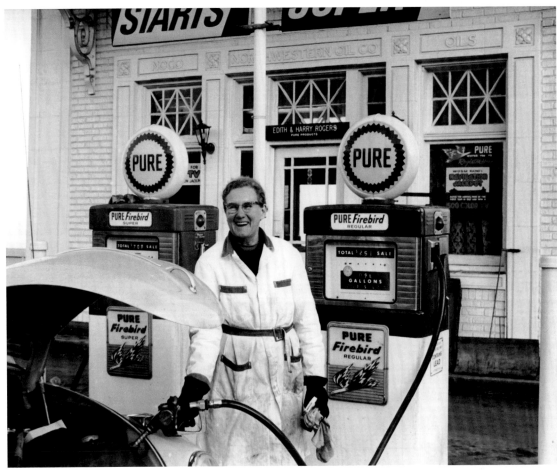

50. Duluth Superior High Bridge and Old Swing Bridge. 1967.

51. Edith Rogers, Co-owner, Rogers Pure Oil Station on
East Superior Street, gas 35¢ per gallon. Duluth, 1967.

52. Benjie, Friend from My Youth. 1967.

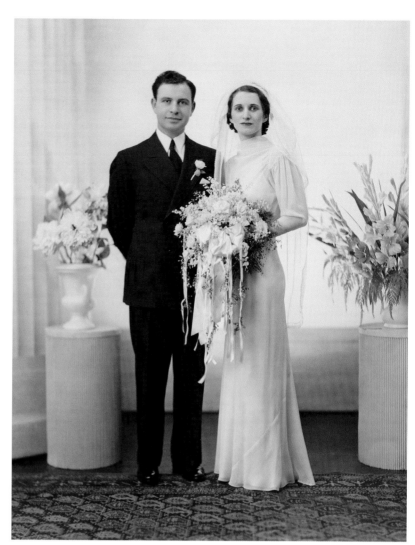

53. Tom and Goldie Wolfe.
Mom and Dad's Wedding Photo.
Duluth, 1937.
(Photographer unknown.)

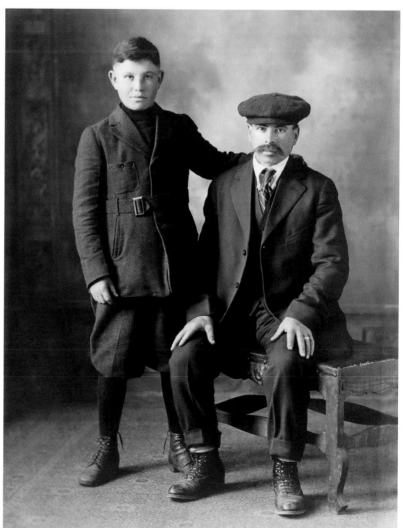

54. My Father and Grandfather,
on a day trip to Winnipeg,
Canada. 1921.
(Photographer unknown.)

Parents

"What you live with you learn, what you learn you practice, what you practice you become, and what you become has consequences."

—Ernie Larson

We all have many stories and memories regarding our parents: some good, some not so good, and some great. I find it so interesting that even as older adults and after so many years have passed, we have many memories preserved from the earliest days, imprinted so deeply that they can be reflected upon as if they happened yesterday.

Both sets of my grandparents emigrated to the West from Eastern Europe in the late 1800s. They were in search of opportunity and the freedom to choose who and what they were to be. My paternal grandfather was a blacksmith and farmer in Manitoba. My mother's father had a grocery store in Duluth.

Dad, the youngest of six children, was born in 1909 and grew up on the family farm in Canada. After finishing the eighth grade he had to leave school and work with his father full time on the farm. In Dad's memoir to our family he reflected upon the brutal winters and what it took to merely survive on the prairie in those early days. He also told many interesting stories about his youth on the farm.

At the age of seventeen, with two hundred dollars knotted in a handkerchief and safety-pinned to his underwear, he came to the United States to help his older brother with his new business in Duluth. It was called the Zenith Interstate News Company, a wholesale distributor of newspapers, magazines, paperbacks, comic books, and periodicals. At the young age of twenty-three he took over the reins of the business after the sudden and tragic death of his brother, killed by a run-away truck. Through years of hard work, along with many trials and tribulations, he developed that business. He was not only respected in the community as a businessman but also for his participation, dedication, and years of volunteer work in many community and philanthropic organizations. All of these fine, honorable and impressive accomplishments were achieved with merely an eighth grade education.

In 1912 my mother, the youngest of seven children, was born in a small house a half block from her father's grocery store. One day while in her teens she was sweeping the sidewalk in front of the grocery store and a mutual friend introduced her to Dad. It was love at first sight.

Mom attended Superior State Teachers College and became an elementary school teacher. She taught for a few years in the small town of Spooner, Wisconsin. Dad would commute there often to visit her. They were very much in love but couldn't get married until Mom's older sister married. Finally, after eight years of courting, they married.

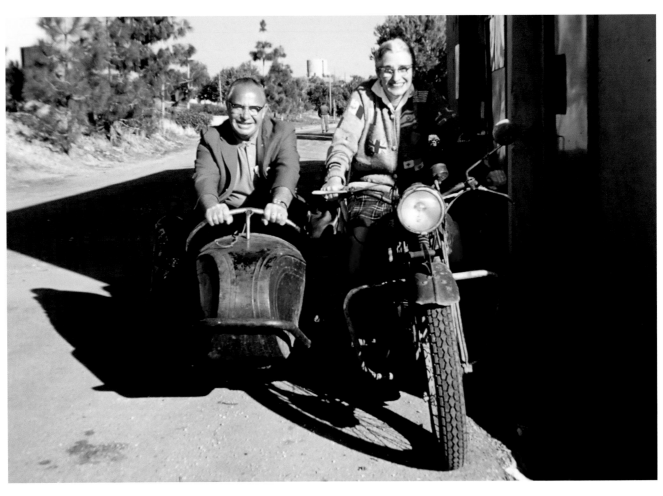

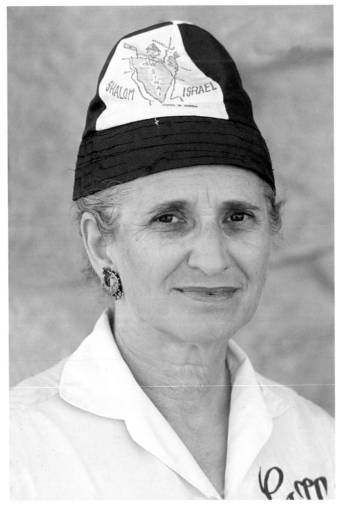

I once took a picture of my parents clowning around on a parked motorcycle with a sidecar. It was a happy and fun photograph of my mom and dad, and yet, so out of character. They were always very cautious and conservative. It wasn't in their nature to take a lot of chances or do things such as sports. But they loved to slow dance and moved with poise and grace. Both of them were kind, polite, honest, caring, and giving people.

They were always very protective of us kids. They worried when I played sports, went into the Marine Corps, went off into the woods with a gun to hunt, or when I took off tramping around Europe, North Africa, and the Middle East with a pack on my back and camera in hand. I liked to zoom around on my motorcycle and do other things that drove them crazy. It wasn't my intention to make them worry, those were just the things I liked to do.

Neither of my parents could swim. Mom would kid that she even measured the amount of water in her bathtub. As a result, they made sure I learned how to swim at the YMCA at a very young age. One day in the summer of 1953, when I was ten years old, my mom had been calling out and searching our block for me to come home. She found out from some neighbor kids that I had gone off skinny-dipping with friends in Chester Creek, down the steep wooded ravine off Fifth Street. She rushed to the scene and caught me dog paddling back and forth across the pond. It wasn't the first time I had partaken in such an activity on a hot summer day, and it was great fun. Mom didn't think of it in that way, however; she was sure that I would drown. While I was hopping around still wet trying to get my pants on, she broke off a small branch from a nearby bush and then proceeded to whip my behind as she chased me the two blocks home.

Although it was the one and only time she used it, from that time on it was called "the Stick." She kept it on top of the china cabinet as a reminder to us kids that, if she needed it, the Stick was there. Once, in a fit of childish frustration and as a demonstration of defiance, I grabbed the Stick, broke it in half, and threw it in the garbage. A few minutes later and without a sound it magically reappeared on top of the china cabinet taped together, once again poised and ready as a constant reminder. I think either my brother or sister still has that taped stick stowed away in a drawer somewhere as a memento of our childhood.

Mom was a sweet, loving, kind, and giving mother, and among other things acted as the family photographer and historian. She took such great joy in using her Kodak and Argus point-and-shoot cameras. The pleasure I saw her receive from the photographs she would take and share I believe to be an early subliminal influence on me as a photographer. She died way too early, at the age of fifty-nine. The intensely emotional experience of her life coming to an end brought with it my first reality of true love lost.

55. Mom and Dad on Motorcycle with Sidecar. Kibbutz Gesher, Haziv, Israel, 1970.

56. Goldie. Israel, 1970.

My dad worked hard his whole life and died in his eighties. He wasn't a very tall man—about 5'6" or 5'7"—but strong from years of lifting and carrying bundles and boxes of books at his business. Like Popeye, he had especially strong hands and forearms.

When I was about eight or nine, I came home from religious school with tears in my eyes and a red cheek. A new male teacher I had that year thought it was cute to pinch kids' cheeks. I could see this upset Dad when I shared this with him and, in his quiet way, he told me he would pick me up after school the next day as he wanted to meet the new teacher.

I remember that at this meeting my dad reached out his hand to shake and introduce himself, and then proceeded to very slowly crush my teacher's hand as he calmly told him that it was nice to meet him, welcome to the school and the community, and "Oh yes, please don't pinch my son's cheek any more." I could see my teacher's smile slowly turn into a cringe and his right shoulder drop down a bit, his hand obviously in pain. I couldn't believe it. It took me so by surprise. Dad was always so gentle and easy going, the perfect gentleman, but I found out that day he could have a temper and only a couple of times did I see him demonstrate it, and if need be, in a physical way. I was so proud of him. I believe it was not only love but also his protective fatherly nature that drove him to it.

He always reminded us about the Golden Rule, and to be honest, fair, courteous, giving, and to do the right thing. Thinking back on the pinched cheek episode, I believe he must have considered his response as justified due to his responsibility to protect a defenseless little kid. I once related this story to a friend of mine who told me of a time his father went to school with him one day. His dad told the teacher, "If little Johnny gets out of line it's OK to beat the crap out of him." Somehow we all managed to survive.

57. Father and Sons at the Wailing Wall. Jerusalem, 1970.

58. Diane and Joel—Mother and Son. Minneapolis, 1978.

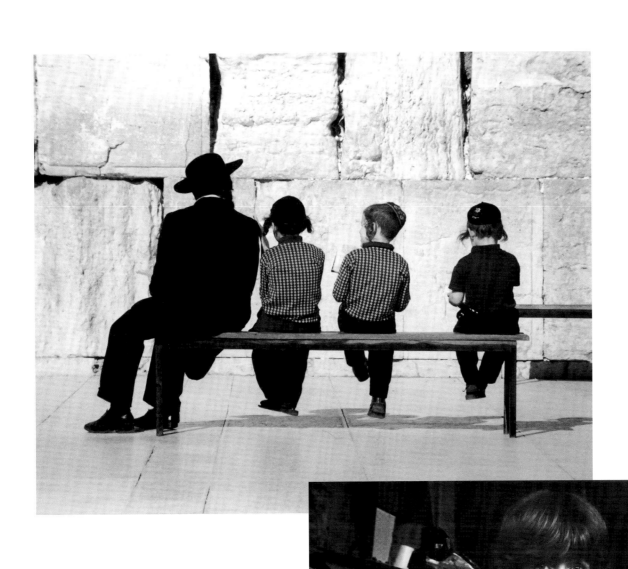

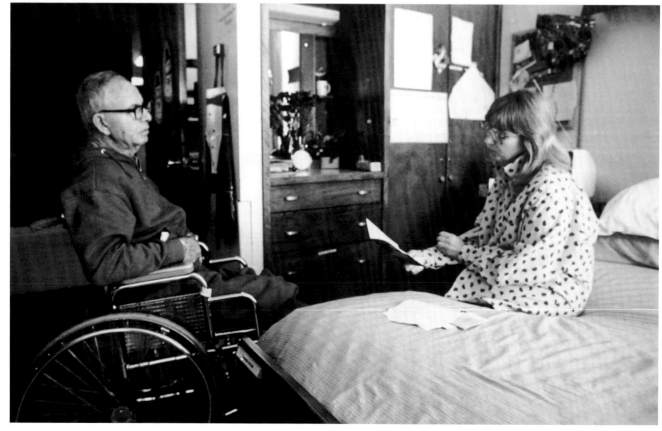

You grow up, become an adult with a life and maybe children of your own, but your parents will always still be your parents. My parents had a propensity to worry about me and fear the worst would happen, but they always took pride in my adventures. Kahlil Ghibran wrote:

Your children are not your children.
They are the sons and daughters of life's longing for itself . . .
You may give them your love but not your thoughts,
For they have their own thoughts.

I always felt blessed that I grew up with such loving and caring parents. When I think of my parents as a couple, they represented to me the epitome of a true-life love story in every sense of the word—that true unmistakable love of a couple. You could just see the love, the warmth, the caring, the friendship.

59. Mom and Dad on my Tenth Birthday. In Front of Zenith News. Duluth, 1952.

60. Mom and Dad at the Red Sea. 1970.

61. My sister Neena reading Dad his mail following his stroke. 1986.

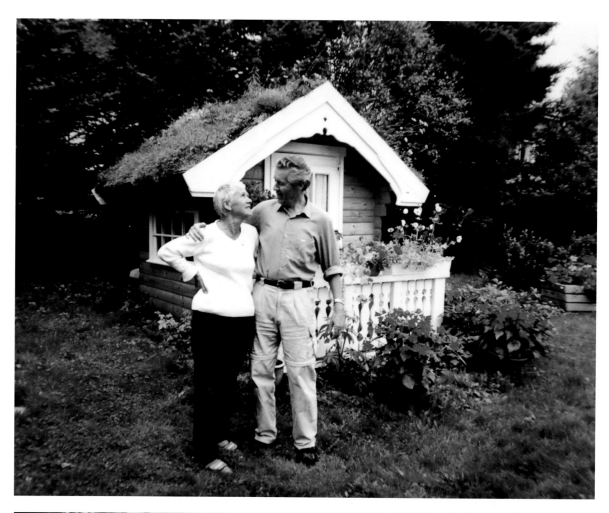

62. Elizabeth and Fridtjof. ("I always wanted a doll house. He built me one when I was 60.") Å, Norway, Lofoton Islands, 2001.

63. Ben and Barry. Isabella, Minnesota, 2006.
It's OK to be romantic and young at heart at any age.

A footnote to that unmistakable love of a couple:

"From every human being there rises a light that reaches straight to heaven, and
when two souls that are destined to be together find each other, the streams of
light flow together and a single bright light goes forth from that united being."
—Ba'al Shem Tov

64. Harry and Doris. Valdez, Alaska, 1995.

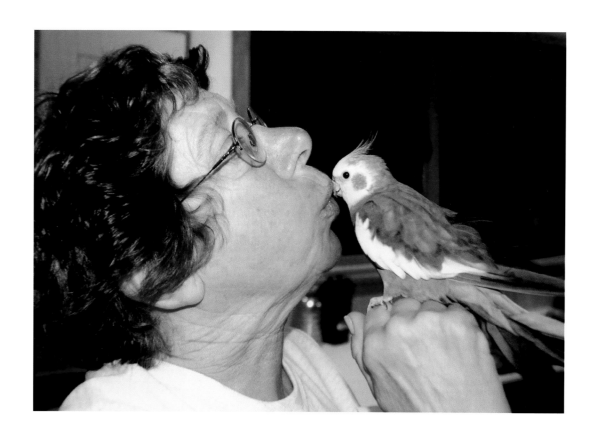

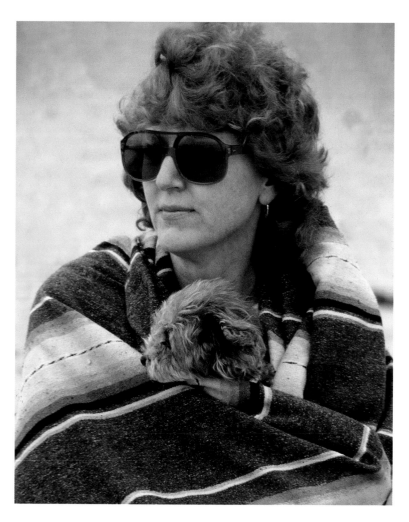

Pets, Life, Death, Loss

Pets are not for everyone, but people who have had pets understand the unconditional love and unwavering devotion animals can demonstrate towards their masters. My experience and that of my family has been with dogs. It seems that most pet owners have a certain unselfish sensitivity, which is repaid in full with such a simple event as the exuberant greeting one receives upon returning home from a day's work. It's a joy to see a dog's excitement when the leash appears indicating that a walk outside is about to happen, or a Frisbee or ball toss is next. The tongue comes out with that canine smile and the tail starts a-wagging. Often you see people not only petting their pets but also hugging, even kissing them, and treating them with new special toys and food treats.

Scientific studies have demonstrated that petting an animal actually helps relieve stress and lower one's blood pressure—a wonderful alternative to the often reckless and foolhardy taking of drugs and pills.

I have heard people say, "Well, it's only a dog," after hearing that someone they know is so sad, mourning the death of their pet. They are remembering the heartfelt, rewarding, and memorable times they shared with their pet. The ties and bonds can become very close. These pets in most cases are considered to be really a member of the family, not just an object. They are creatures that in my estimation can truly exhibit special energy, spirit, companionship, friendship, affection, even love. Their loss can be in many cases quite devastating. People can raise and keep a pet for many years and look at it as one of the more reliable entities that helps gel the family.

As the pet gets older, the physical complications that accompany its advancing years will also become part of the family's deepening experience of life's rhythms. Often it is the children who learn a most graphic and important lesson, coming to understand death, loss, and grief as a part of life. The experience and sequence of seeing, understanding, and accepting this reality, along with the importance of grieving, then moving on with life. Remembering the good energy and positive fun times with that passed spirit. It brings to mind the Native American shaman, teacher, and tracker Stalking Wolf, who constantly reminded his apprentice Tom Brown "to give thanks and to praise the Spirit that moves in all things."

Gunther Von Hagens wrote, "As I become older I regard death as the absolute normal and life an exception. To understand life you must embrace death."

65. Susan and Sitiva. Fairfax, California, 2005.

66. Diane and Spooky. 1980.

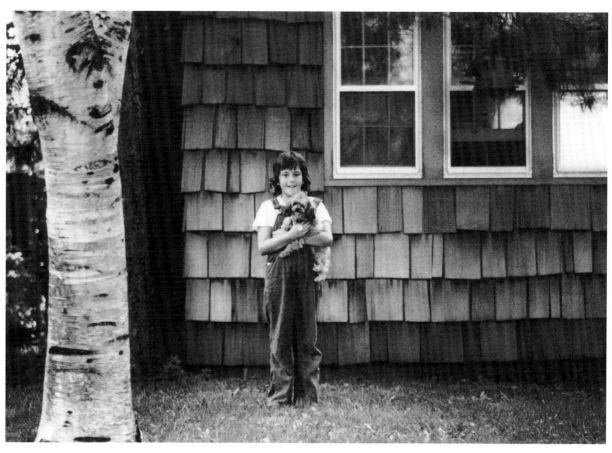

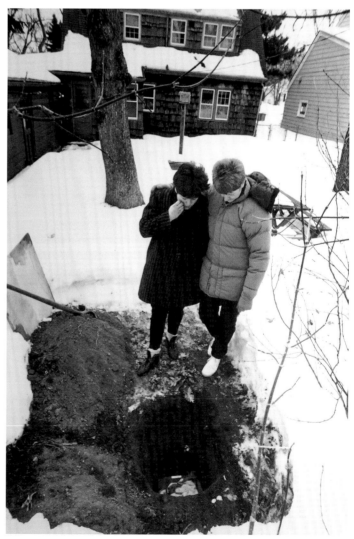

There are many things in life that can be very painful and difficult to accept. As we live we discover that one of the consequences of love is the pain of loss. So I say— Reach out and embrace Life with a sense of meaning—love, laugh, cry, feel, share, be.
 Live Life.

"Death leaves a heartache no one can heal,
 Love leaves a memory no one can steal."
 —from a headstone in Ireland

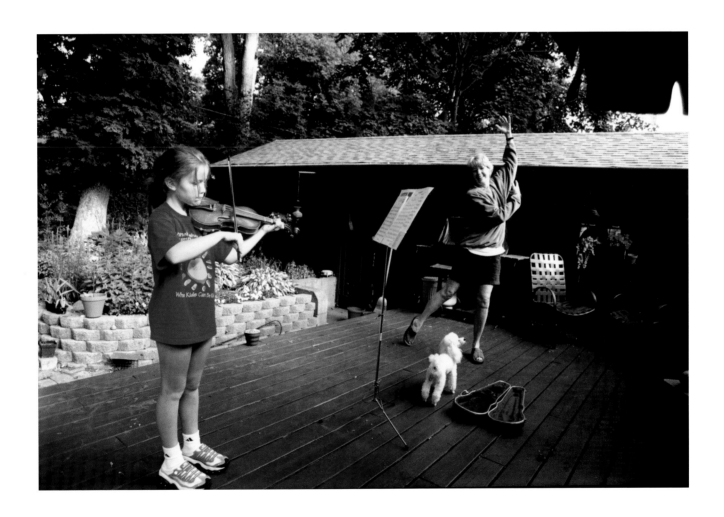

67. Joanne, age 9, with her little 3½-pound pal Spooky. 1973.

68. Joanne, age 23. Saying goodbye to Spooky, her little pal of 15 years, Joanne and Diane. 1986.

69. Alex, Diane and Sonny—Celebrating to the Beat of Life. 2002.

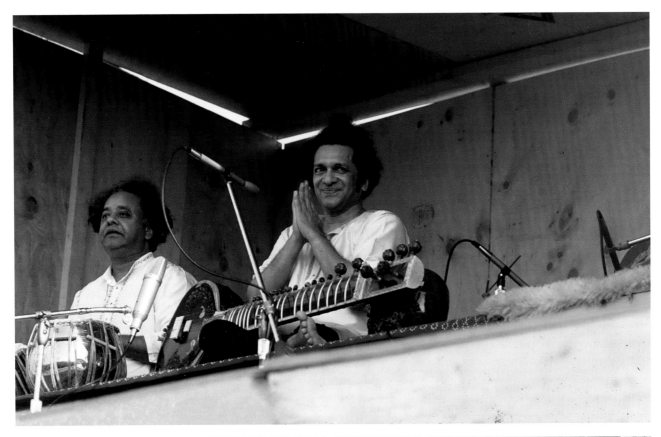

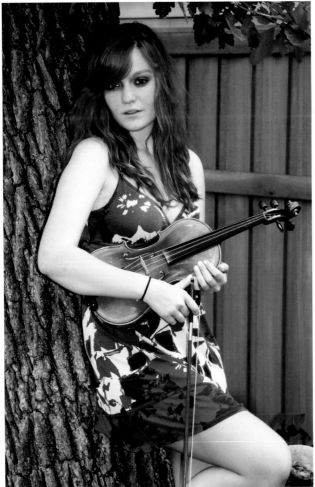

70. Alla Rakha and Ravi Shankar. Stevens Point, Wisconsin, 1969.

71. Alex at 16. Minneapolis, 2009.

72. Ryan. Dundas, Minnesota, 1972.

The Music Makers

I have been drawn passionately to several diverse areas in the arts. One of my favorites, which has helped me not only to enjoy life more but also sooth my soul, is music. I have great respect for the dedicated music makers of all genres and enjoy most types of music. However, I am primarily drawn to classical and jazz. Over the years I have spent literally thousands of hours in the darkroom, and music has been my partner and my friend, helping me and putting me in the mood to truly feel what I am printing.

My granddaughter Alex has been playing the violin since she was five and has participated as a member of the Greater Twin Cities Youth Orchestra (GTCYS) for several years. I still reflect upon a time in 2002 when all of the GTCYS orchestras performed a concert in Minneapolis at Orchestra Hall. The children ranged in age from eight or nine to eighteen and were at different levels of proficiency. The grand finale involved all of the orchestras—called "The All Ensemble"—playing Gustov Holst's *Jupiter*, a personal favorite. The senior-most orchestra was on the stage and the rest of the children were standing, filling the aisles and the balconies. I was so taken by the fullness of all these young people playing together, an elbow's length away from us. In the same way the music so totally filled Orchestra Hall it totally filled me, to the point where it literally took my breath away and brought tears to my eyes. It was truly a most beautiful and spiritual experience.

It is said that when Holst's *Jupiter* was being practiced prior to its debut concert, the women mopping the floor of the performance hall stopped, listened, and then began to dance with their mops. That is truly music that penetrates your soul. There are many things in music that have the ability to stop you in your tracks and make you feel the music down to your core. It can affect us all differently, as we are different in what we like. For me, a smattering of the music that moves me most would include: The opening iconic clarinet solo of George Gershwin's *Rhapsody In Blue*. The simple three notes played by the double string basses in the early part of Edvard Grieg's *Morning Mood*. Aaron Copland's *Fanfare for the Common Man*. Milt Jackson's incredibly beautiful sounds on the vibes, and the remarkable music created on the harmonica of Toots Tillman. The Stradivarius of Joshua Bell and the flute of Sir James Galway. The unmistakable sound of Paul Desmond's saxophone; the voice of Luciano Pavarotti singing *Nessun Dorma*; the tabla of Alla Rakha, and the guitar of Sharon Isbin; the flute of Carlos Nakai; and so many others just too numerous to mention.

It's that amazing ability of the music makers to take the few notes that are available on the scale, then manipulate, juxtapose, stylize, time, and temper them into the auditory phenomenon known as music. Some styles are fast, some slow, some soft and sensuous while others are loud and gruff, even brutal at times. The musical creations of John Cage, for example, are heard as incomprehensible, even annoying, to some, yet thought of as brilliant by others. All of these clever and

diverse manipulations of those few notes of the scale are truly special, having the ability to entertain the ear and at times the entire body.

It has been my observation when photographing or conversing with musicians that no matter their degree of proficiency—whether amateur or professional, whether they are part of a garage band, members of a symphony orchestra, or a performing soloist—they all seem to share this incredible passion. You can just see their enjoyment and enthusiasm when they play or merely discuss their music. This passion for music goes beyond the composer whose imagination creates it, the performer who plays it, and the conductor who directs it. It also includes those like me who just love to listen and truly feel and appreciate this wonderful gift of music.

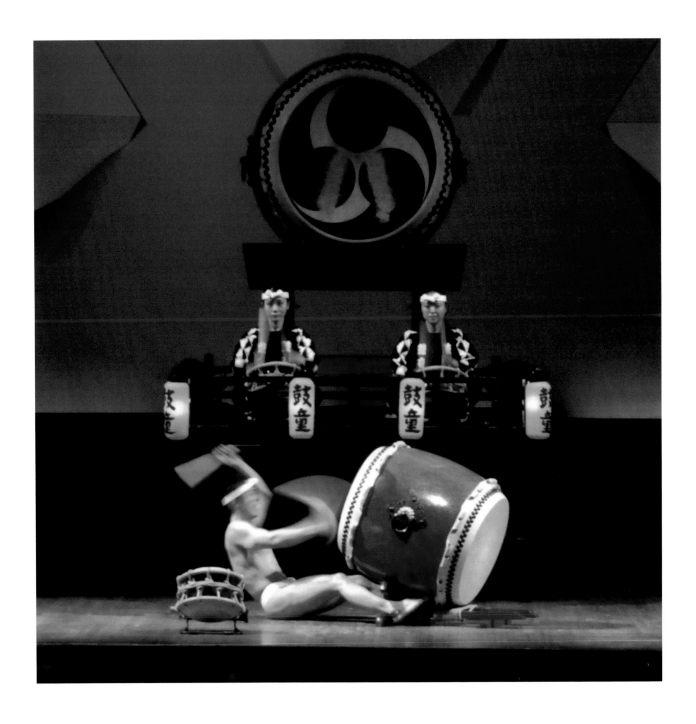

73. Japanese Taiko Drummers. Minneapolis, 2009.

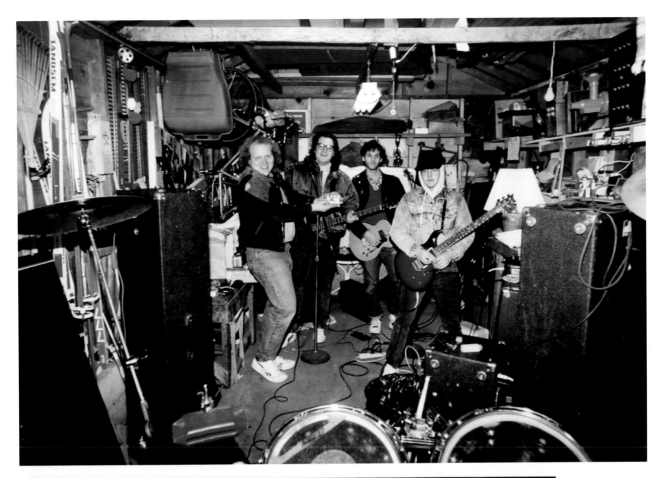

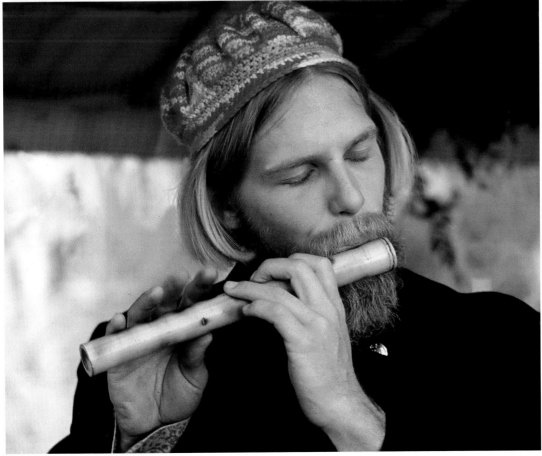

74. The Thunder Bats. Minneapolis, 1988.

75. Man with Flute. 1969.

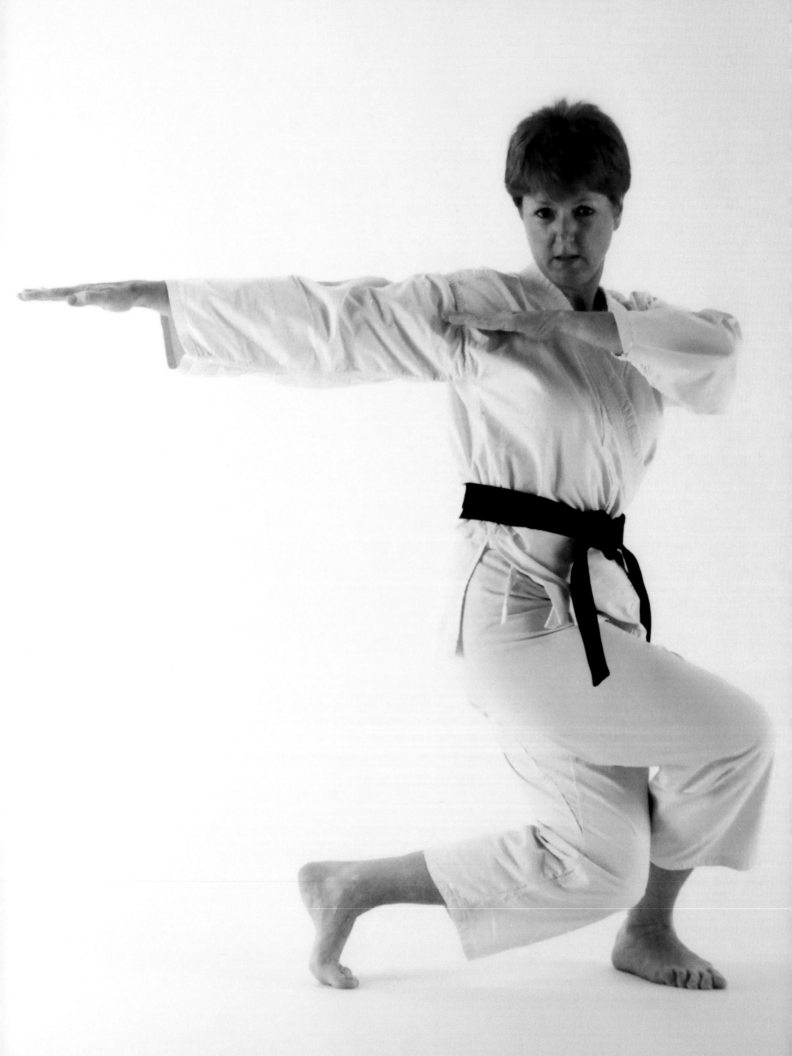

Martial Arts

Tomorrow is a worthy opponent that may never come. Still—the warrior prepares!

Another form of art that I have been drawn to is martial arts. This has been a major influence on my life and how I try to live it. I have trained in traditional Japanese GOJU-Ryu karate for over thirty years and twenty years in Iai Do. Iai Do is a silent, non-combative discipline, emphasizing the aesthetics of the ancient art of Japanese sword-drawing techniques. Over the years some of my favorite subjects to photograph have been martial artists. My objective has been to capture the beauty and grace of the practitioner's form. Dave Lowry alludes to this in his book *Autumn Lightning*: "The quality of their *Shibume*, the aesthetic quality of severe simplicity. *Shibumi* is quiet, graceful, and hidden beauty, usually found in an everyday object or in nature." This is in opposition to the depictions used to sell movie tickets or those full-contact spectacles emphasizing blood-splattering, bone-breaking brutality.

There are many reasons why people are drawn to the martial arts: for the physical fitness and health benefits, for the discipline, for the joy of sparring, or for self-defense, to mention a few. I initially began my study for the physical fitness and health aspect, but I soon learned that there was so much more: discovering deeper, more subtle elements and meaning, along with acquiring self satisfaction and fulfillment through my involvement.

The traditional martial arts are looked upon as educational, not as recreation, entertainment, or sport. They are also not to be entered into whimsically or taken lightly. They involve a discipline in which one can participate and be involved for a lifetime. As with so many arts, it requires diligent practice and effort in one's training and study to have a chance to discover the hidden essence of its higher meaning.

It is not just about getting in shape, sparring, or self-defense, but also a means to develop self-awareness, self-confidence, self-esteem, and self-control. Self-control both physically and emotionally. Developing good honest character and integrity along with sound social ethics. Striving toward being able to resolve conflict in a peaceful manner. It is also important to remember that, as a martial artist, one must continue to keep one's skills tuned and sharp but, more importantly, to use one's weapons wisely. To be in control of one's thoughts and actions is the highest level of responsibility—to use one's knowledge and skills as a means to help focus, center, and improve one's life and those around them.

The Japanese martial arts, with their origins in the feudal, unstable, and warring periods of Japan's history, became among other things a means of self-preservation. This concept of *Budo*, or the Martial Way, was also accompanied by a strict set of rules and ethics. Today, it is a way of developing a human being to become

76. Diane, in Kata Saifa. 1986.

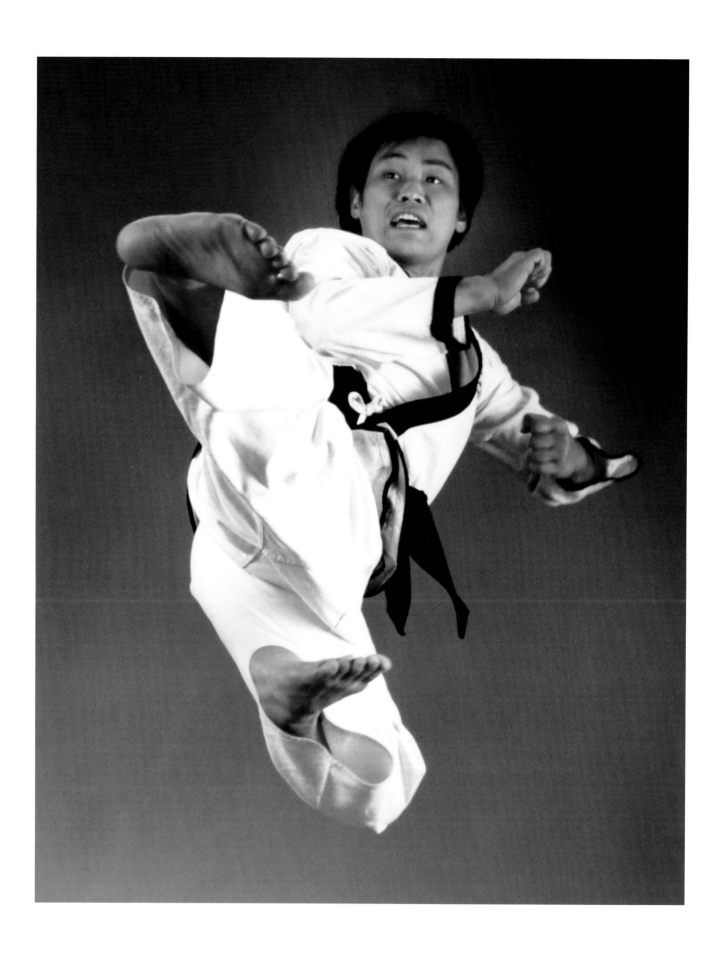

a positive, peace-loving member and asset of society. Unfortunately, these arts are commonly presented in the movies and on TV demonstrating brutality. This obscures the true philosophy of traditional karate and Budo, which actually emphasizes the quest for honor, loyalty, and peace.

Considering the concept of sports, I think sports in general are a wonderful way to teach young people about sportsmanship and goodwill, along with training both the body and mind. There are the setting of personal records, then the goals to try and surpass these and make new records, which then become rewarding achievements along with the sheer enjoyment of the game. This participation in sports can continue its interest, involvement, and excitement right through to adulthood. My kid brother, now sixty-one years old, was a terrific high school and college athlete, and to this day still plays ice hockey with a senior league, of which he is one of the most senior seniors.

In many sports today a great deal of emphasis is put on becoming number one, no matter what. This, along with the involvement of big business in sports, unfortunately results in something other than sport. It is really the quest for fame and fortune, with, I think, the emphasis being on fortune. A child is introduced to an athletic, fun game, which ends up turning into the cutthroat and glamorized sport of big business. You can see fans drawn so passionately into becoming part of the quest to become number one that some will go so far as to tattoo a team's logo on their body. Their exuberance has led them on occasion to rioting, where people have actually died and property destroyed following either their team's victory or loss. In so many cases, the true idea of sport and athletic participation has been lost, metamorphosing in the relentless drive to be number one. The sense of conquest comes to surpass and veil such important elements as ethics, sportsmanship, and fair play.

In a traditional style of martial arts there is nothing to be recorded. The solitary fight is to know one's own spirit, which, in essence, becomes the battle against oneself. The point is not to compare oneself to someone else but to search out and develop one's own spirit. Here, you don't see the practitioner, after sparring or presenting a form, jumping up and down and doing a crazy victory dance, or shooting off a lewd gesture to his opponent, guest, or fan. This is something you might see after a professional football player makes a tackle, or a touchdown, or after a fight during a hockey game. Quite to the contrary, the traditional martial arts speak to becoming humble. This, in a direct sense, requires one to concentrate fully on one's inner strength and spirit, and to remember that everyone and everything in our lives is important. All so easy to say, yet so hard to do.

"I sincerely believe that we judge a martial artist by his humanity and maturity rather than his strength and speed."
—Kensho Furuya

77. Merrill Jung. San Francisco, 1987.

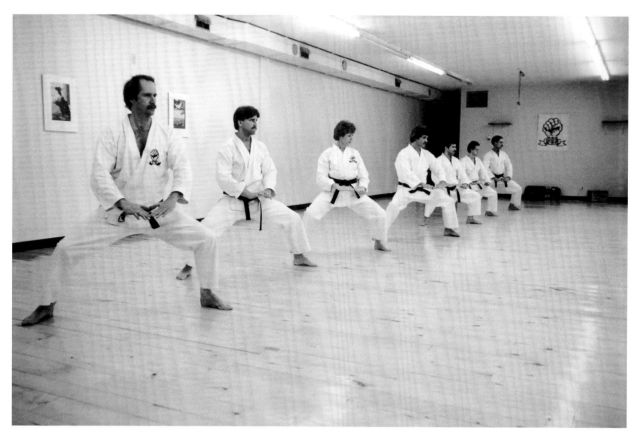

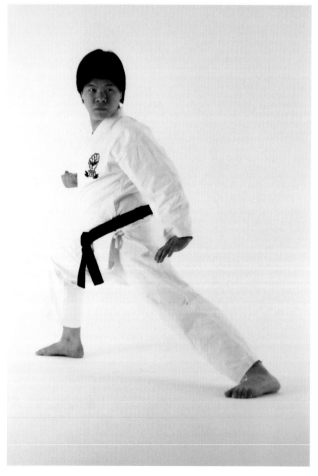

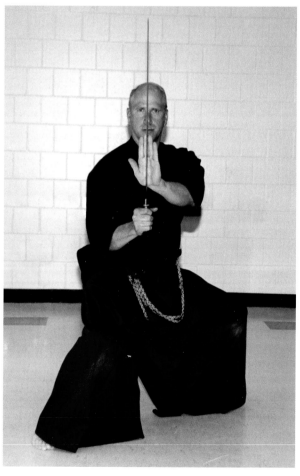

78. Kata Seinchin. Minneapolis GOJU-Kai
Karate School., 1987.

79. Michael Wong. 1986.

80. Tom Dahlstrom. 2003.

81. Mr. N. Gosai Yamaguchi,-Hanshi,
Chairman GOJU-Kai Karate-Do USA.
San Francisco, 1999.

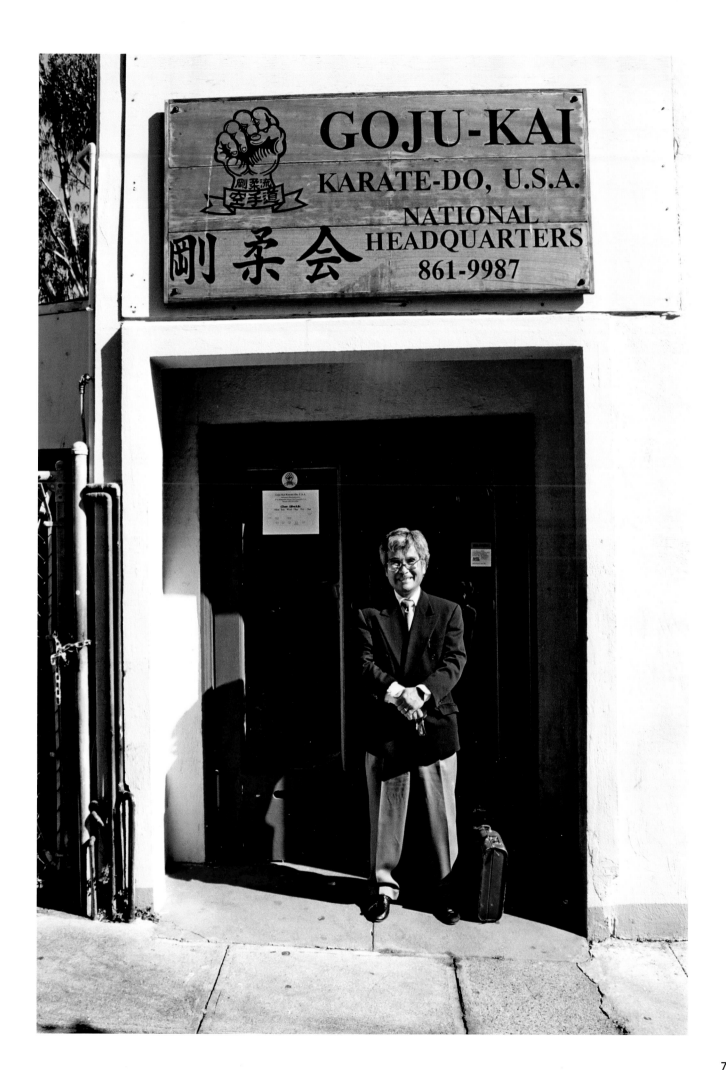

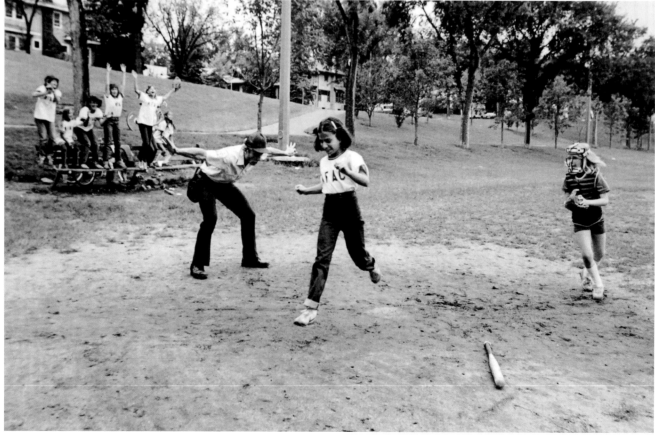

Children's Books

"Writing for children is murder. A chapter has to be boiled down to a paragraph. Every word has to count." —Dr. Seuss

Over the years I have been fortunate to be involved in the production of children's books. It has been a treat working with Learner Publications and the Oliver Press, both based right here in Minnesota. In addition to the images created, the experiences I have had researching the projects along with the photo sessions themselves have proven to be not only fun but educational for me as well.

I created my first children's book in 1981: *The Truck Book*. It was a basic overview on a variety of trucks—what they looked like along with a basic text of what they did and how they worked. It was "geared" to the very young.

In 1983 I collaborated with my wife Diane to co-author and photograph the second book. Because of our medical backgrounds—mine as a biomedical photographer and Diane's as a nurse, in addition to being a wonderful photographer—we were asked by the publisher to create *The Emergency Room* book. This was directed toward grade-school children, depicting how the E.R. worked and what to expect in the event of an unexpected trip to this oasis of care.

Next came a twelve-book series on *Sports For Me*, followed by many fun craft books and a three-book martial arts series. Then a thirty-book international cookbook series designed for the upper grades. In these the publisher incorporated maps and cultural notes. The idea was that, as a cultural geography project, the student, with his or her parents at home, would prepare recipes from the books, giving a taste of the diverse possibilities of the culinary arts that exist around the world. Each book contained approximately fifteen recipes and photographs and quickly became a favorite of many school librarians. I might add, this was a very tasty set of books to create.

The most recent series I have worked on is *How It Happens*. The subjects range from building a house to factories making candy bars, cereal, frozen pizza, ice cream, motorcycles, and trucks. How the U.S. Postal Service works, along with how fireworks are made and displays set up and choreographed.

Although the business of books is changing due to things like the computer and the Internet, I still like to sit down in a comfortable chair with a book in my lap and savor that personal experience. I also hope the traditional book business survives for the sake of the children. It's that experience of communication and sharing of a story with a child, on a parent or grandparent's lap, that helps sustain warm and lasting memories.

82. David's Home and Office on the Road. *The Truck Book.* 1981.

83. The Winning Run. *Softball Is for Me.* 1982.

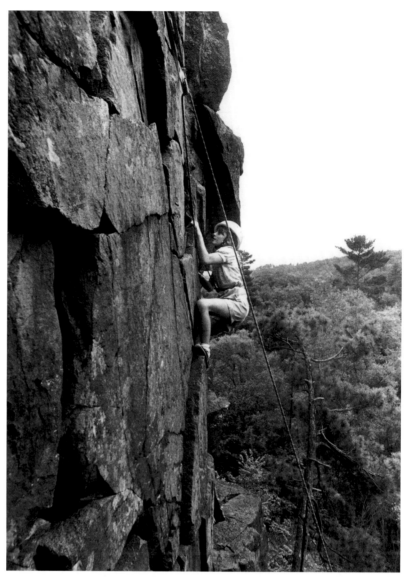

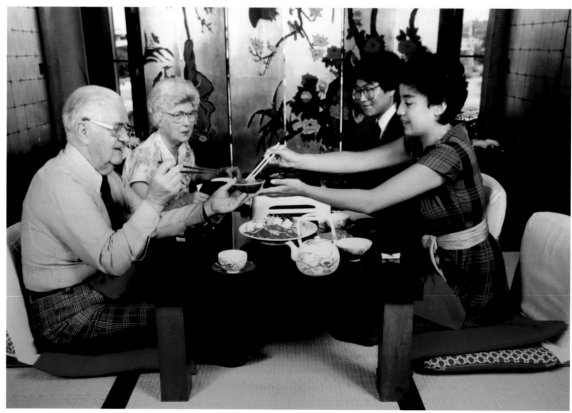

Also, with regard to changing technology, I still prefer to sit down and write with pen and paper. My wife tries desperately to make me stop scratching down notes on Post It notes, napkins, and little bits of paper, and get myself a laptop. I'm sure one day I will acquiesce and go that route, as I have recently started to produce more work digitally. I still very much also like to shoot the old way with film, due to the fact that another passion besides taking photographs has been the joy of printing both black-and-white and color images optically with an enlarger. This special and classic means of physical manipulation and control over my images is what I like to refer to as "the magic dance of the dark," with each piece having its own unique choreographed moves. Ah yes, technology.

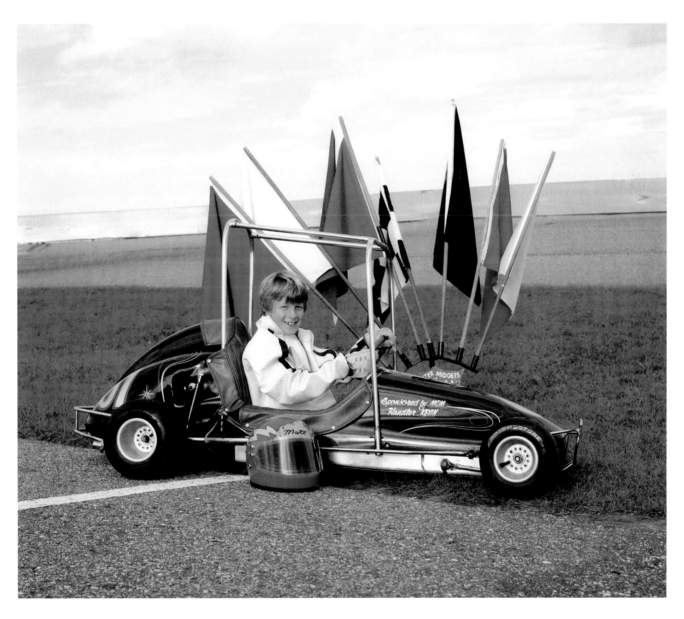

84. *Rock Climbing Is for Me.* Taylors Falls, Minnesota, 1984.

85. *Cooking the Japanese Way.* Minneapolis, 1983.

86. *Quarter Midget Racing Is for Me.* 1981.

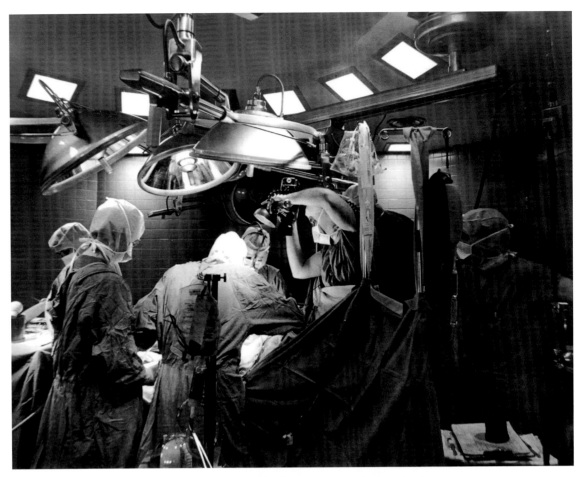

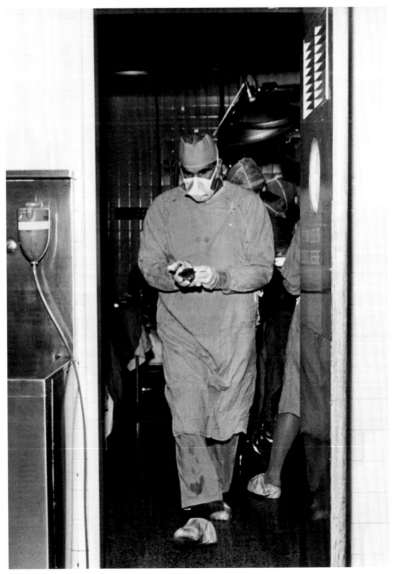

Biomedical Photography

On April 1, 1969, I joined the biomedical photography staff at the University of Minnesota. My first position was that of assistant photographer, then I became a medical photographer, and, a few years later, senior medical photographer. It was in the early years of kidney transplantation headed by Dr. John Najarian. There was also revolutionary heart surgery by such notables as Dr. Richard Varco, Dr. Richard C. Lillehei, and Dr. Dimitri Nicoloff. Exciting work in other areas included genetic research by Dr. Robert Desnick, innovations and developments in radiology by Dr. Curt Amplatz, and Dr. Ted Buselmeier's work with shunts. These, along with so many others, were making explorations and advancements in many fields of medicine, researching and teaching at the University of Minnesota Hospital and Health Science Center. Some of these doctors were young but quite brilliant. Others were well seasoned, having gained knowledge and wisdom over the years.

My day would begin at 7:45 a.m. Most often I was called first thing to go straight to the O.R., the operating room, to record an ordinary or extraordinary procedure or anomaly. Sometimes it would require being present for nearly the entire procedure, other times just for a brief interlude—to step in, take the photograph, then step back. Some days I would be shuttling from one operating room to another, photographing everything from brain surgery in one room to a hemorrhoidectomy in another. Basically, from one end of the anatomy to the other.

The day was full from beginning to end, and the phone in our department was constantly ringing: an assignment in the O.R., a patient to be photographed, a specimen to be shot, a photomicrograph to be set up and recorded, a studio equipment shot, even public relations photos from time to time along with portraits of staff and group shots. If there were something to be photographed, we would get the call.

It was an exciting and most interesting environment, working alongside such enthusiastic, dedicated, creative, skilled, and energetic people. Many of these medical people became very close friends of mine over the years, and I respected them all as incredible craftsmen and craftswomen of their trade. I also respected them for their humanitarian choice of vocation and their dedication. Observing first hand the tedious, precise, and demanding work required of the surgeons and their long, grueling hours. The ever-inquisitive perseverance of the researchers while researching a disease or anomaly in their search for a solution and cure. The individuals and the teams, all working toward the common goal of making life better for humanity. I felt honored to be part of this work. I also felt dedicated to

87. Author Photographing Surgery. University of Minnesota Hospital. 1976.
Photo by Sam Cohen.

88. Dr. John Najarian carrying kidney from Donor Room to Recipient Room, circa 1973.

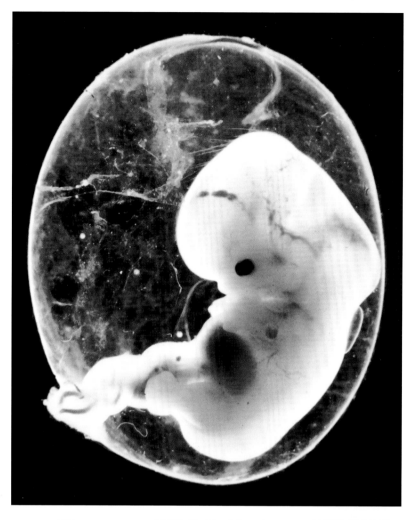

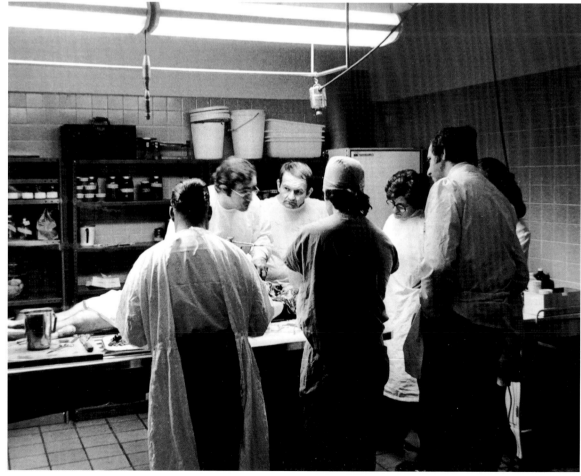

this cause through my work as a photographer, depicting and recording things in the quickly changing and evolving field of medicine.

Another special and serendipitous event that occurred while working at the Health Science Center was that I met a cute nurse: a red-headed, freckled-faced, blue-eyed beauty named Diane, who soon became my wife and soul mate. We now have a son, Joel; a daughter, Joanne; and two granddaughters, Alex and Olivia, all of whom have appeared continuously in the viewfinder of my camera.

After working for seven years in the medical trenches, I experienced a burning desire to make a change—to take a chance and a leap of faith, to explore other areas in photography. In 1976 I was offered the opportunity to develop and teach a course in biomedical photography at the Minneapolis College of Art and Design. It was to complement a new program in Biomedical Graphics that would be taught by Martin Finch, a talented medical illustrator and also the head of the University of Minnesota's Biomedical Graphic and Communications Department. The course lasted three years and was well received and very successful. However, as I understood it, the college administration decided that the thrust of the school was to follow a more fine art avenue, and as a result the biomedical program was discontinued. The students were wonderful and it was a great teaching experience.

During those seven years on the job as a medical photographer there were so many untold but remarkable events that took place: from the mundane "pots and pans," as photographers refer to the more generic studio setups, to life-and-death events. Some of these came quickly and unexpectedly while others lingered. From the births, both normal and happy, to the heartbreaking stillborn and ectopic pregnancies. From the successes in surgery, to the last stop at the hospital for those less fortunate: the morgue. From the micro-cell explorations under the microscope to the large pieces of equipment. Sometimes entire rooms or labs, even architectural exterior shots of a building for a publication or brochure. Patient photography, specimens, x-ray reproduction. Surgical procedures, recorded with still photography and at times with 16mm cine film. Micro and macro photography. All of these, showing the normal or the abnormal, the unique, the bizarre.

Some of those photographs were just another photo in a day's work, while others tugged at my emotions. Like getting to know a patient as a human being through the numerous photo sessions observing and recording their deterioration, right up to the end. The tragic scene of a person with over ninety percent of their body burned so badly that it would only be a matter of time. Observing the heartbreaking yet sensitive care of the medical personnel, whose job it was to keep that patient as comfortable as possible until then.

I have witnessed the joy and relief of a patient and their family when they receive the news that everything is normal and going to be OK. There is also the

89. Fetus, approximately six to seven weeks old, from unruptured ectopic pregnancy. 1976.

90. The Morgue. 1975.

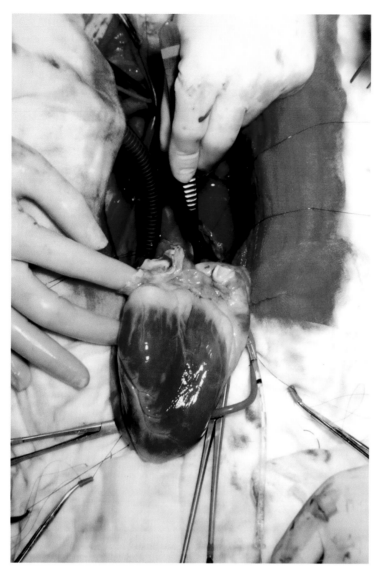

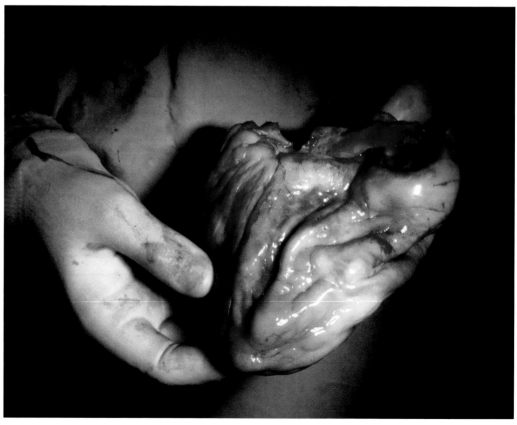

sadness and despair when the news that comes back is not so favorable, possibly even with a dateline as to an expected end.

There were many wonderful, positive, happy outcomes, like those brought about by the skilled work of a surgical team. For instance, all the elements of the remarkable process of a heart transplant: The donor, the recipient, and both families. The skill and knowledge of the surgeons, along with that of the entire team. The anesthesia and bypass, doctors, nurses and technicians assisting. Then, the surreal, unforgettable feeling, looking into the empty chest cavity of this living human being after the damaged, inefficient, worn-out heart has been lifted out and removed. Now the donor heart rests in position, poised and ready to find a new home, to bring life. The new heart is put into place and attached to the recipient's vessels. Then that magnificent first beat and the beginning of a truly new life—the gift—the rebirth.

When our kids were teenagers, we let them drive the CJ7 Jeep we called "Rusty" and our old green VW bug we nicknamed "Old Paint." I would tell them that these cars run not only on gas but also on oil, and to be sure and check the level often. One day I happened to look out the front window as our daughter was heading out in the Jeep. It went about two feet and then jerked to a stop. . . . Hmmm, no oil.

I picked up a good used motor out of a wrecked car at the junkyard, rented an engine hoist, and, with the help of my old pal Diek, after a few days transplanted the new motor right in our driveway. It took time and a little knuckle busting, but because it was an older and somewhat simple machine, it wasn't really that complicated to fix. When I think about changing something in the human body, such as a kidney or a heart, it seems absolutely amazing to me. To be able to give the gift of life and renewed health is really quite remarkable. Who knows what the future will bring?

I view this period in my career, recording such unique and remarkable events, as being incredible special and unforgettable.

91. First human heart transplant performed in Minnesota.
March 4, 1978.

92. The Badly Damaged Heart, result of a massive heart attack.
March 4, 1978.

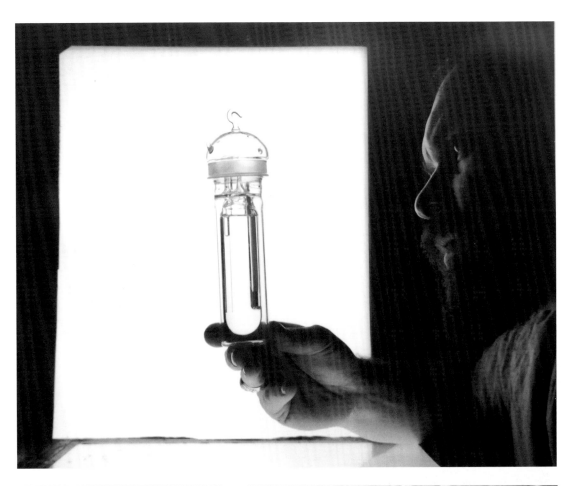

93. Self-portrait. Setting up a Studio Shot. 1975.

94. Photomicrograph, normal blood cells and cycle cells, magnification 700x. 1974.

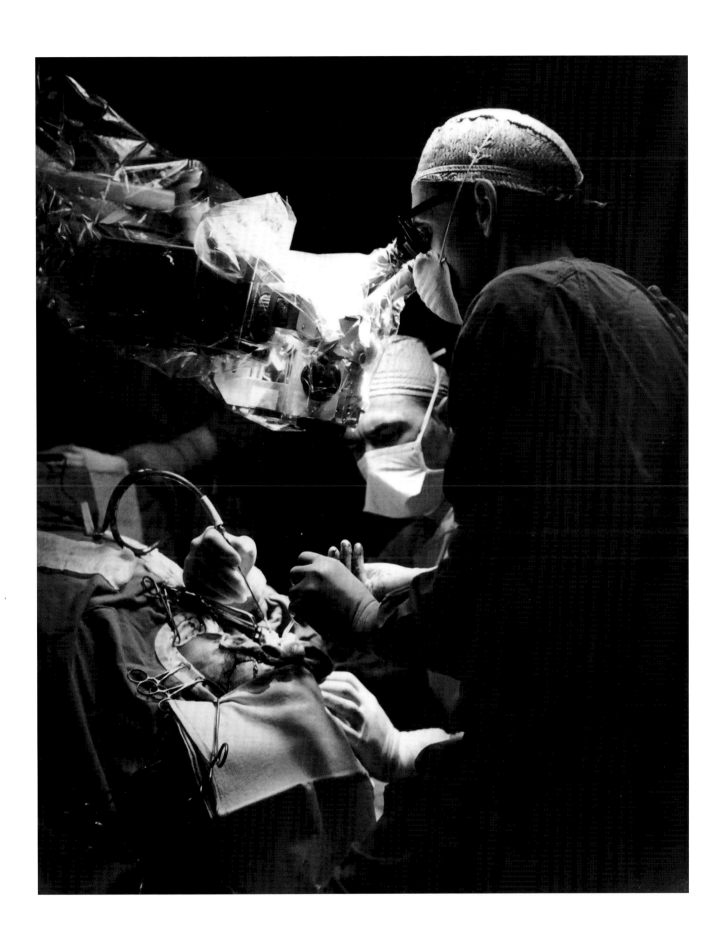

95. Dr. Jim Ausman, Neurosurgeon. 1974.

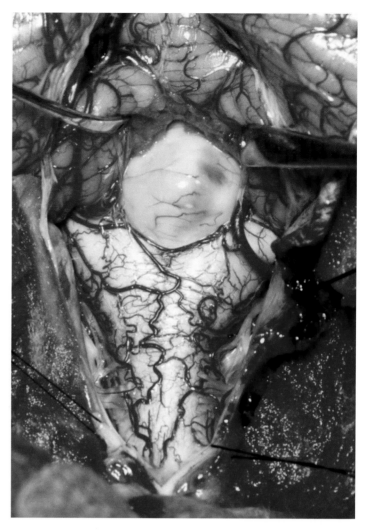

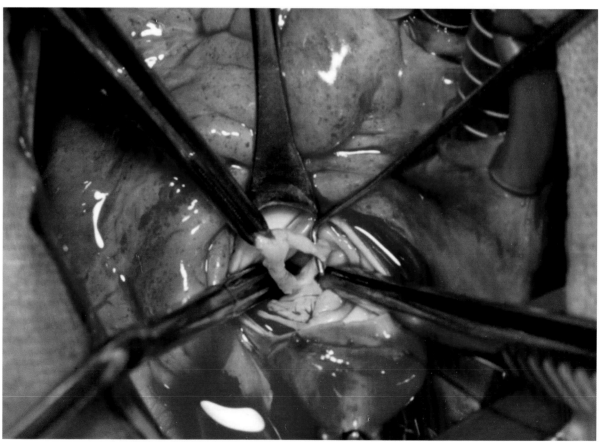

96. Neurosurgery, retractors shown exposing a tumor at site of the brain stem. 1976.

97. A stage in open heart surgery on a three-year-old child illustrating the repair of a heart valve. 1975.

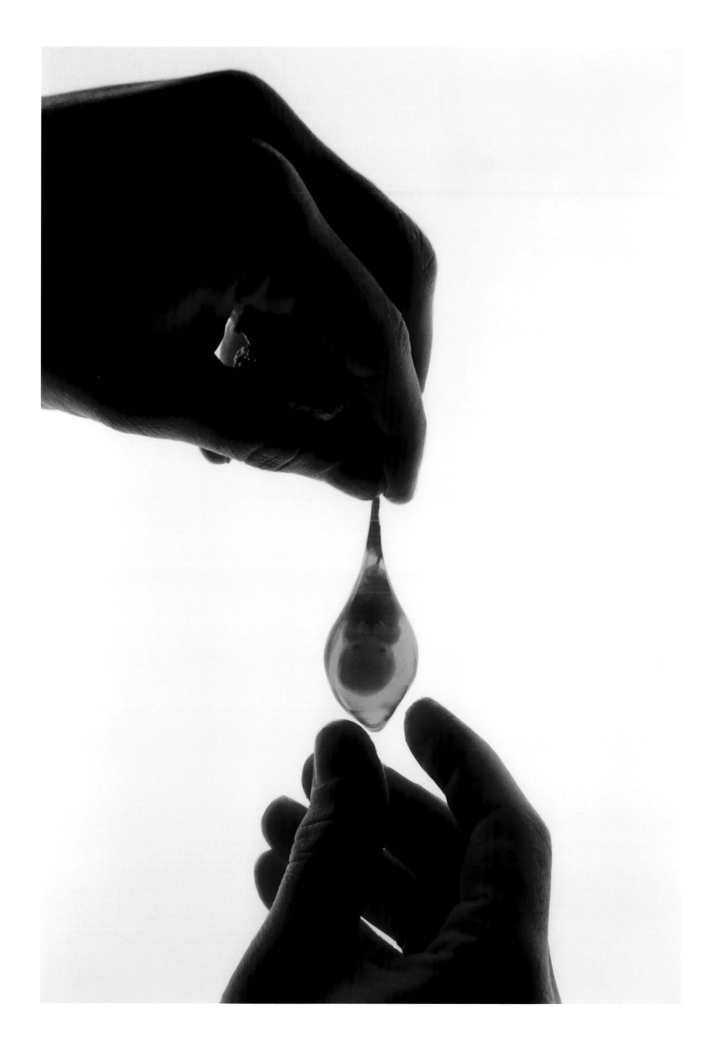

98. Fetus, approximately eight weeks old, from an unruptured ectopic pregnancy. 1972.

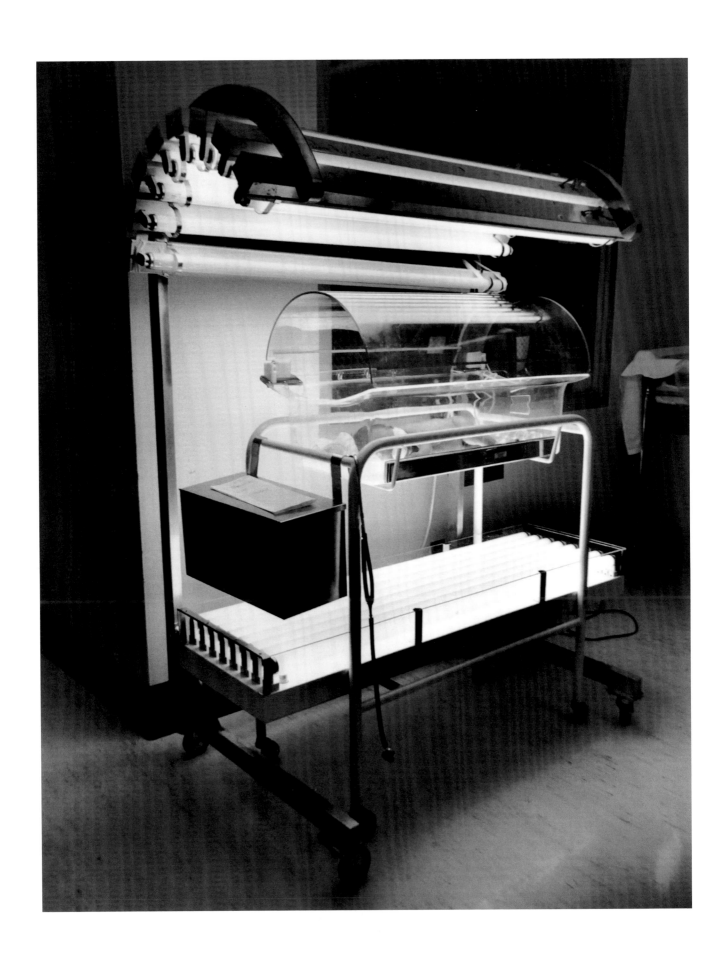

99. Bilibed, phototherapy lamp treatment for newborn jaundice. 1974.

In terms of health and wellbeing, we deal some hands to ourselves while others are completely out of our control. Accidents happen, along with natural disasters, wars, epidemics, and there are genetic predispositions that lead some toward certain conditions and illness. On the other hand, there are many things we do to help protect ourselves and hopefully bring along a better quality of life—such as not smoking, choosing what to eat, getting exercise, resting both body and mind, always wearing a seat belt, and if you have teeth, flossing them!

"Live long and prosper!"

—Mr. Spock (Leonard Nimoy)
First Officer of the Star Ship *Enterprise*

An interesting footnote: The Vulcan salute is a hand gesture Nimoy devised based on the Priestly Blessing performed by Jewish Kohanim with both hands thumb to thumb representing the Hebrew letter Shin. The letter Shin here stands for Shaddai, meaning "Almighty (God)." The accompanying spoken blessing, "Live long and prosper," is similar to common Middle Eastern greetings (shalom aleichem in Hebrew and salaam alaykum in Arabic) meaning "Peace be upon you," and its reply, "Upon you be peace."

100. Stained Glass Window. Jewish Synagogue. Sosua, Dominican Republic, 2000.

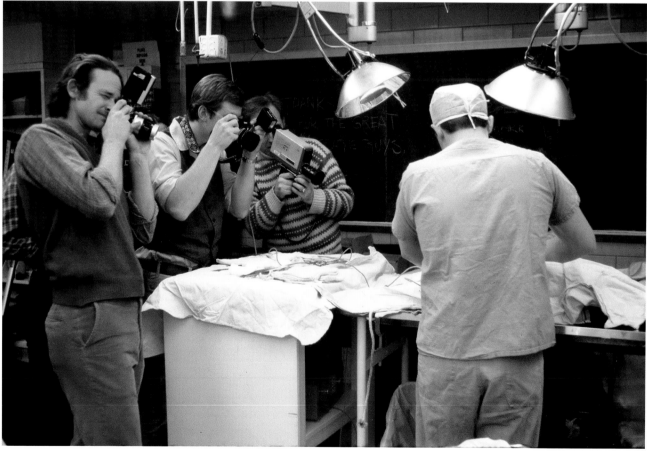

New Horizons

In the summer of 1976, right after leaving the Biomedical Graphics Department, my wife and I packed up our two kids and little dog and took off on a six-week cross-country trip in our 1969 VW camper van, affectionately referred to as "Tilly." It was a time to decompress, spend time with the family, and sort out my next move in photography. Upon returning home from the trip, I was asked to accompany Dr. John Schwarzwalder to Israel to film a documentary for educational television entitled *The Open Door*. It was to probe the question of equality for the Arab who lives in Israel. Upon returning and finishing that project, I opened my little studio at 124 First Street North—a thousand square feet on the second floor of a small building in the warehouse district of downtown Minneapolis.

I had a nice steady industrial photography account with the Graco company, which specializes in pumps and spray gun equipment; a remodeling firm that kept me busy photographing interiors and exteriors; plus the one-day-a-week teaching job at the art school to get me started in my business. I took just about every photography job that came my way. It may sound crazy, but at one point I got so busy shooting that I nearly forgot to bill out jobs. This enjoyable menagerie of photo jobs, projects, and experiences in my studio and on location began to slow down in 1982. The economy was at a real low point. Business was very slow, budgets were being cut back, and everyone it seemed was tightening their purse strings.

One day I was dropping some film off at the Linhoff Photo Lab to be processed, and the co-owner of the lab, a friend, asked how business was. I told him it was really slow and jokingly said that I might just ask him for a job one day. He responded that they were actually looking for someone new to run the custom printing department, and the rest is history. I became a full-time custom printer and ran the custom-printing department for twenty-five years.

The job gave me enough freedom so that when a freelance job came along, or an old customer needed some photo work done, or a children's book was to be shot, I was able to take the time to shoot. Also, on two separate occasions in the 1990s, I took a two-month hiatus from the lab and traveled to Alaska with my wife in our little 1987 VW camper van. Both trips were incredible photographic adventures.

As time passed and digital photography became more and more popular, the custom print department went from five full-time printers to one. 2001 was the year when I became the custom-printing department. As I write this I am still spending the better part of four days a week at that lab.

101. Wolfe Racing Team. Bonneville Salt Flats, Utah, 1976.

102. Biomedical photography students observing procedure in research lab. University of Minnesota Health Science Center. 1977.

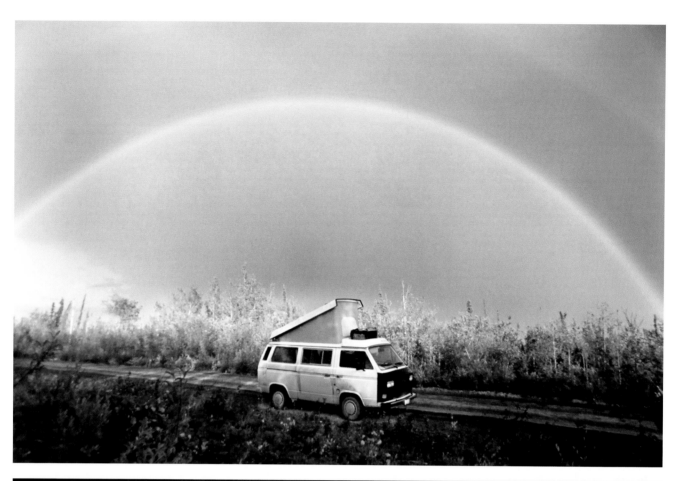

Over the years I have printed thousands of other people's negatives and transparencies, for both professional and amateurs. Thousands upon thousands of custom-enlarged, one-at-a-time, handcrafted prints. All during this time I continued to shoot my own work, trying to keep expanding upon what I truly enjoy in photography.

Although I enjoyed what I was doing at the lab, at times it became frustrating that all day every day involved the printing of other people's work. I would continue to tell myself that one day I'd get to my own images. It was so difficult after a full day's printing at the lab, then a couple hours of martial arts training, to go home, fire up the equipment in my own lab, and start printing my own work. Choices again, I guess—to secure a steady paycheck and health insurance along with taking care of all the other responsibilities, disciplines, and interests in one's busy life. There is an old saying: you can't chase two rabbits.

But little by little, year-by-year, my images are getting printed. There is also the excitement of printing a negative I may have shot decades ago which has remained dormant in the files, just waiting to be printed and come back to life, recreating a long-past experience. (True confessions of a frustrated artist.)

For the past couple of years, working from a pile of old notes and journals, I have written and rewritten this little story. It reminds me of the painter who is never really satisfied with a piece of work and continues to paint, working and reworking the piece. Finally I became somewhat satisfied with what I had come up with and I decided to send the manuscript off to an old pal of mine, now retired. He used to teach English, later became a school principal, and now dabbles a bit in writing short stories. I don't write for a living, and I was anxious and excited to get someone else's thoughts about what I had written.

My friend agreed to read it, saying he would be honored, but even before looking at it he remarked that he too had thought about writing a story of his life experiences, but didn't think it would be interesting to anyone other than his family and friends. I didn't quite know how to interpret his remark. Was it a gentle way of telling me not to be disappointed in the event of total rejection? I replied that first and foremost I am a photographer. In the past, the stories I have told have been through the lens of my camera. Much of the reflections, little stories, and armchair philosophy I am striving to share in this writing encompass experiences which have been greatly influenced by what I have photographed—not by my personal history alone.

Life can be a crapshoot, and you really don't know the outcome until you have taken a chance and thrown the dice. I truly hope this writing of mine will act as an interesting, informative, and entertaining introduction to my photographs, as well as serve as an explanation and chronology of some of my work and experiences. I hope it will be accepted and enjoyed by others, and not only by my family and friends . . . but only time will tell.

103. Waiting Out a Rain Storm with a Broken Alternator Belt.
Road between Minto and Manley, Hot Springs, Alaska, 1993.

104. Arc de Triomphe, Champs Elysees by Night. Paris, 1970.

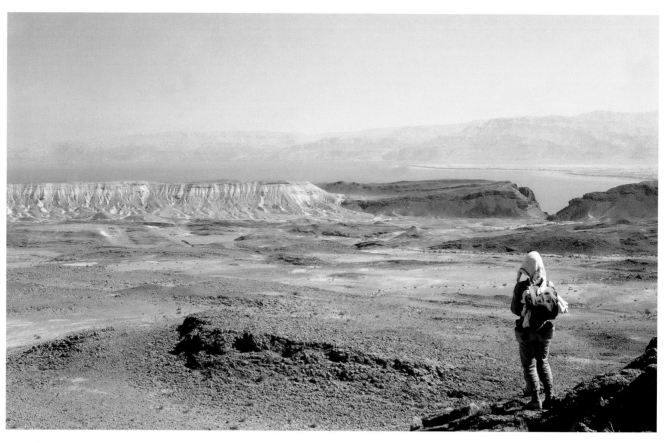

105. Negav Desert Overlooking the Dead Sea. 1963.

106. Cowboy. Monument Valley, Utah, 1992.

So here I am, now sixty-seven years of age, and for the past forty years I've been chasing my dream. As I look back on those years, whether I realized it at the time or not, I truly was living most of that dream—from learning and manipulating and enjoying the tools of my trade, to the people I've met, the events experienced, and the images made. My life has also included the special element of being part of a loving and caring family, and the time I have spent exploring and enjoying other interests and disciplines.

A few years ago I ran into an old friend in a coffee shop. Some years before he had a wood shop on the first floor of the building my studio was in, and he made beautiful furniture. He too had been affected by the economy in the eighties and closed his wood shop. Now, as part of his new career, he restored the elaborate woodwork of interiors in old elevators. After our handshake and cordial greeting he asked me, "So are you famous yet?" I replied, "To my kids I am."

107. Bar Mitzvah Boy. Israel, 1975.

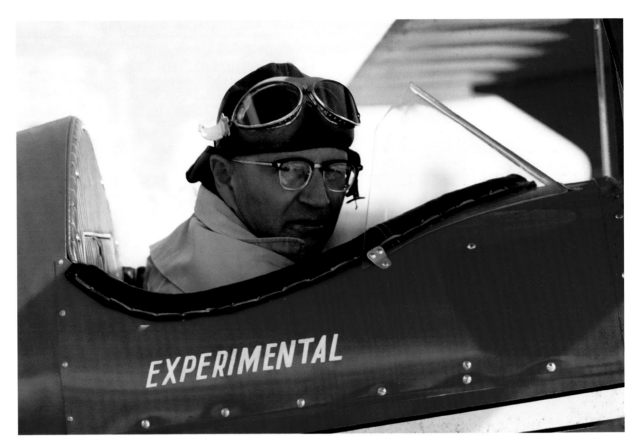

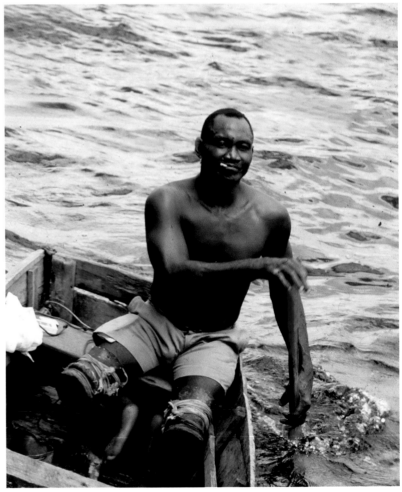

The Human Factor

All of us have our personal lives and stories. Our fears and secrets, our loves and desires, fantasies, jealousies, hopes, and dreams. To win the lottery, win the big game, become famous, be loved, or merely be accepted. The list can go on: to secure gainful employment, buy a new car, have food for the day, a warm bed, a roof over our head, or simply to live in peace and freedom. What we see of one another is merely a glimpse. Everyone has a story. Everyone is a son or daughter. We are all more than just protoplasm. We are complex and unique. We are human.

I am so moved and inspired by the masters of all art forms. Then there are the scientists, researchers, and healers along with the men and women of peace who have made such remarkable contributions. Devoting their whole being to a great purpose, even at times sacrificing their life for the betterment of man. Sometimes I think about my own contribution. As a visual image maker, what is it I can do or make or give without thought of ego or my fifteen minutes of fame? Something that might remain as a positive contribution for posterity, after the ashes have blown away and been recycled into tomorrow, which then quickly becomes yesterday. What does it really mean, anyway? Will this earth and this human race survive? I hope so.

On Rosh Hashanah, the Jewish New Year, a ram's horn is sounded all over the world. It is a signal to wake up, to look around at our world and at ourselves. How can we be better? How can we make the world better? Basically, how do we conduct ourselves in this world and how do we treat our fellow man? All we can really do is to work on ourselves and act as a good example. Easy to say, hard to do.

Being a Leo, I ask myself: is it ego, or am I just truly happy to be alive and able to share these experiences through my photographs? Not all of these images are positive, beautiful, earthshaking, or truly important contributions to mankind. Nonetheless, the sharing of my life through them brings me joy, and hopefully also others who view them.

"If we should be so lucky as to touch the lives of many, so be it. But if our lot is
 no more than the setting of a table, or the tending of a garden, or showing a
 child a path in a wood, our lives are no less worthy."

—Kent Nerburn,
Small Graces

108. Captain Experimental (unknown pilot). 1968.

109. Guyana Boatman. Essequibo River, Guyana, South America, 1970.

110. Boy with Chickens. Israel, 1967.

111. Pie Boy, Fourth of July. Makana, Wiscosin, 2006.

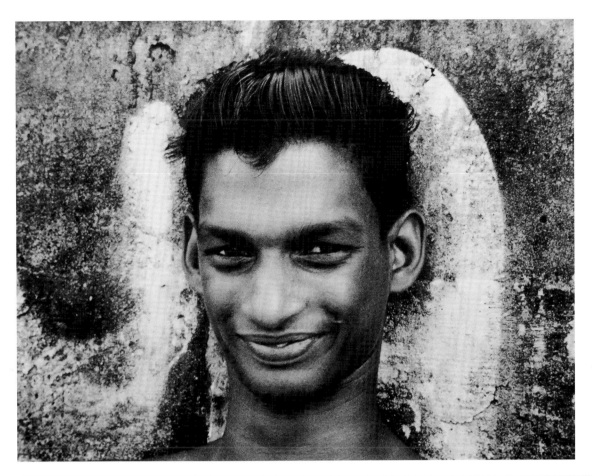

112. Champion Swimmer. Bartica Guyana, South America, 1970.

113. Young Entrepreneur, circa 1970.

114. Stone Lake, Wisconsin, 2001.

115. And they're off! Stone Lake, Wisconsin, 2001.

116. Stone Lake, Wisconsin, 2001.

117. And they're off! Stone Lake, Wisconsin, 2001.

One can only imagine the thoughts flying through the mind of a youngster, sitting in a colorfully handpainted wooden crate on wheels, preparing to race down a hill on a chilly fall afternoon in a small northern Wisconsin town. Along with the excitement, anticipation and maybe a touch of fear, perhaps it also includes dreams of a future as a professional race car driver, jet pilot or astronaut. Time will tell.

And they're off!

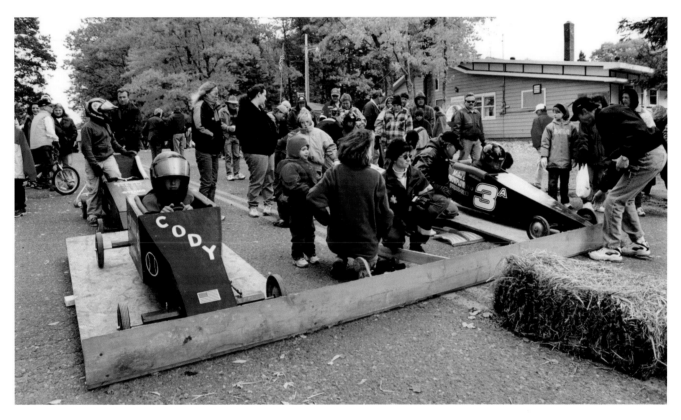

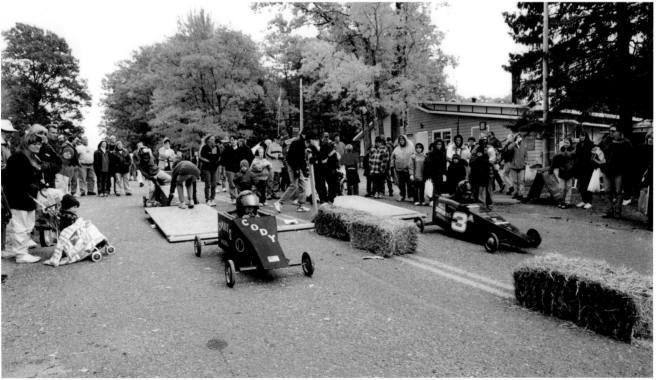

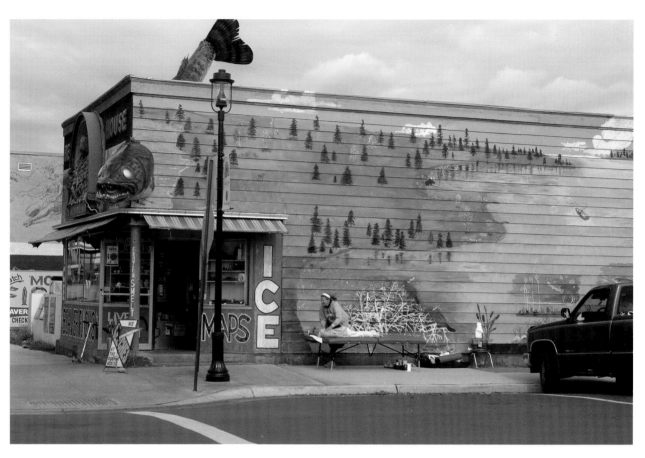

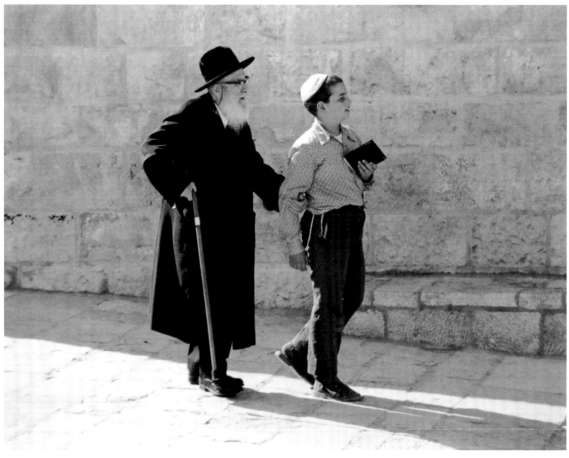

118. Ice, Maps, Frozen Smelt, and Therapeutic Massage.
Grand Marais, Minnesota, 2006.

119. Jerusalem, 1975.

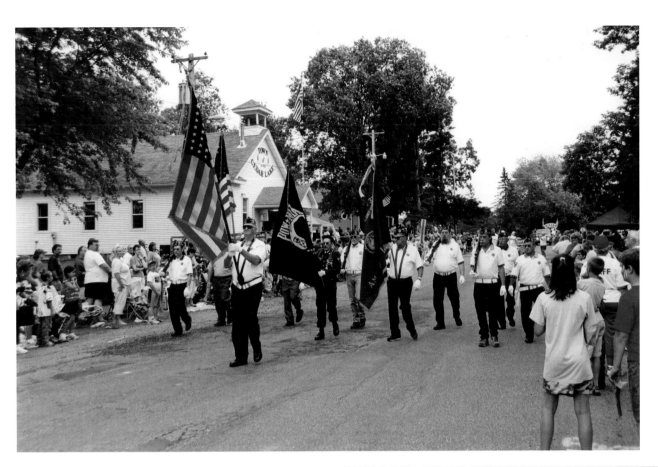

120. Veterans Color Guard, Marching to the Beat of Freedom.
Makana, Wisconsin, July 4, 2005.

121. Brother Ben, Peace Corp Worker, on Vacation. Barbados, 1972.

In the performance of our daily tasks, one may possibly reflect upon the effort given toward those good deeds we at times bestow upon others. While being either grandiose or quite simple in nature, in many cases they may not prove to be

122. Barry—Educator, National Ski Patrol, Fighter of Forest Fires.
Lutsen, Minnesota, 1969.

financially rewarding, however, they can bring one the satisfaction and fulfillment of displaying an honest sense of moral goodness, along with virtuous character, while striving for quality and dignity of behavior and living.

123. Diane—Nurse, Wife, Mother, Artist, Teacher, Friend. 1972.

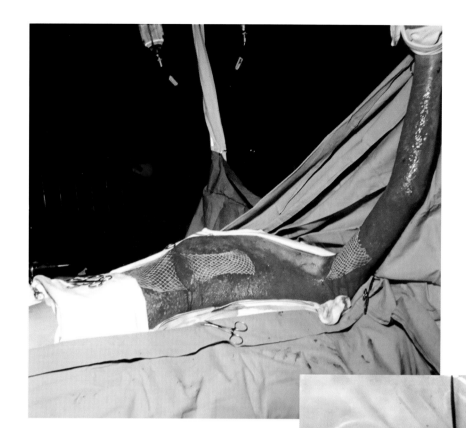

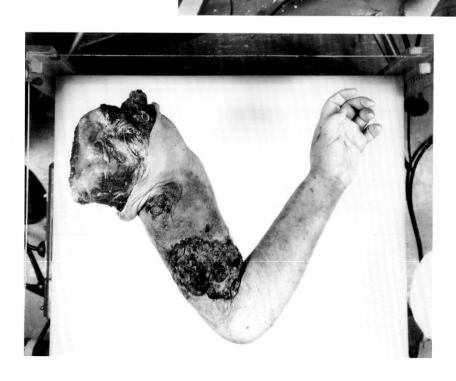

So, What's Normal? What's Real?

What's really real and what really matters? Perhaps it would be those we love: our parents, our spouse, our children or friends. Is it fresh air, clean water, our memory, nature, the miracle of birth, or possibly our window of existence itself? How about our physical capabilities? Everything from that which we consider simple to those revered as remarkable. From the roll of the dice with our DNA, to the ability to walk, talk, see, and hear. To communicate, and to love. To busily prepare for events, often without being aware that we are actually living our life during that period of preparation.

There are uncountable stories of war, atrocities, terrorism, and personal disasters that we hear about and sometimes experience directly. One vivid example involves a cousin of mine who lives in Escanaba, Michigan. We resemble each other and when together are mistaken for brothers, so I refer to him as Brother Mike. Mike is an Army veteran, avid outdoorsman, hunter, fisherman, high-school teacher, coach, family man and all-around nice guy. One day, in his late fifties and just a couple years away from retiring, he woke up as usual, had his coffee, read the paper, drove off to school, and, while involved in a sports activity with the students, suffered a freak accident that in an instant left him paralyzed. He spent several months at Courage Center, a rehabilitation facility in Minneapolis, where we were able to spend time together visiting, sharing stories, observing his progress, and talking about the future. Mike's spirit, humor, and understanding of his situation, along with his acceptance and positive outlook in the face of such a devastating experience, not only for him but his entire family, has been truly inspiring. It is an example of human will, hope, and meaning—to live and make the best of this new and most difficult situation. He evokes courage and zest for life. I view him as a true warrior, and a hero in my eyes.

Humankind is a perishable commodity, but it can also be unbelievably resilient, both physically and emotionally. There is the reality of devastating tragedies that not only change our lives personally, along with that of our families, but also the course of history and a culture. With these events it can be so hard to bounce back. The healing process takes time, whereas the shattering of hopes, dreams, and hard work can occur in the blink of an eye. And, incredibly, life goes on.

124. Skin Grafting on a Burn Patient. 1975.

125. Eye Surgery. 1974.

126. Amputated Extremity Lying on Specimen Table. 1975.

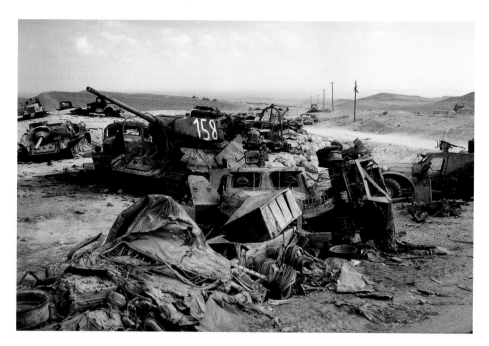

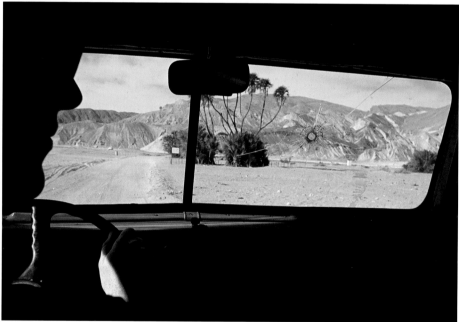

While observing our world, we can reflect upon its wonders, mysteries, and tragedies—all of the things learned, and all of the mysteries and events yet to be discovered and embraced. We have the ability to create and to destroy. What is it that drives man to choose one over the other? Is it love or lack of it? Perhaps greed enters the equation. Is it not ever being happy with one's lot—is nothing ever enough? Is it a quest for power and prestige—is it ego, insecurity, shame, inadequacy, revenge—or can one discover self-satisfaction and fulfillment simply by being OK with who we really are?

So what is it that we are looking for in this life? What makes us happy and content? I've enjoyed the philosophy of Joseph Campbell as he shares it in *The Power of Myth*:

"People say that what we all are seeking is a meaning of life. I don't think that's what we're really seeking. I think what we're seeking is an experience of being alive, so that our life experience on the purely physical plane will have resonance within our own innermost being and reality, so that we actually feel the rapture of being alive."

I personally feel that sharing this life in one way or another is an important factor in achieving that rapture, hopefully leading one towards happiness and fulfillment.

It is also so very important to have a respect for all life. We each create our own reality, and with this in mind we should try to understand people who are creating an experience of reality different from ours. Their way isn't wrong. From that understanding, hopefully there comes greater tolerance, and along with it, compassion. We all want happiness, joy, and inner peace—it's just that we have our own unique way of going about it.

"Could a greater miracle take place than for us to look through each other's eyes for an instant?"

—Henry David Thoreau

127. Mitla Pass, Sinai Desert, 1967.

128. The Death Seat. Sinai Desert, 1967.

129. 9/11/01. Live from New York: 2nd World Trade Center Tower Collapses, 10:28 a.m., 2001.

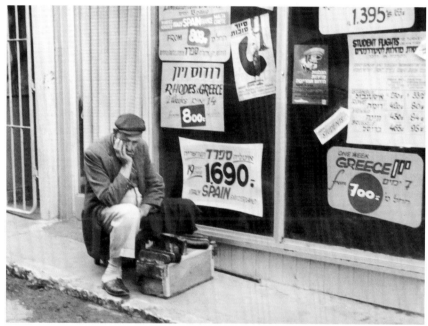

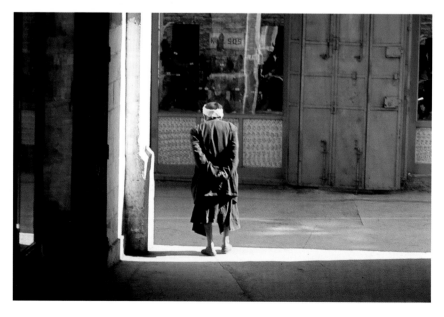

In Retrospect

There is that old cliché: *A picture is worth a thousand words.* That picture represents a personal story to the maker. It is his emotional involvement in creating and communicating the essence of the vision as he deeply feels it, which, in turn, inspires the imagination's thousand words.

Recently I read a most enjoyable book of short stories by Kevin Kling, a local writer and humorist, depicting everyday events from his life. It made me think that, as a photographer, my life is composed of thousands of short stories, depicted in the images I photograph.

Photography has taken me to many places, and I have been witness to many faces and events. I have been merely an observer of some and a full-fledged participant in others. Photography has helped me to *see*—opening my eyes and my heart and expanding my world. I feel most fortunate and grateful that I have had, through my chosen medium, the opportunity and freedom to express my personal feelings. The things I have seen and experienced through photography most definitely have influenced the way I live. They are a part of my life, and an important factor in my appreciation for the many wonders and gifts of this life.

Civilizations, cultures, and worlds come and go. Our modern discoveries become ancient history in time; what is left? What survives? What will become of this fast-moving, revolving, evolving, creative and complex creature known as man? The human race—where is it headed? My hope is that it will elevate us to a place where we can be part of a nonjudgmental, non-cynical, non-prejudiced, nonviolent, more tolerant, loving, caring, and peaceful world. It is a very tall order to place on the table of the future, but nonetheless a dream of many.

We all have our lives and our memories of those times. As a photographer, I feel I have a special way to retrieve, remember, and share those times through the photographs I have taken. Although I derive great pleasure from returning to many of my old images, it is not my intention to dwell in the past. I look at them as a reminder that I have not only spent a great deal of my life in a little dark room recreating these images, but that I have also been an observer and active participant in this life. Photography has helped me to see and appreciate my life, catching up with the past, trying to live fully in the present, and looking forward to the future. At present, I have one foot in the past, while taking baby steps into the present.

130. Paper Boy, 4:45 a.m., -12° F.
Preparing to Deliver the Sunday Paper. Minneapolis, 1975.

131. Shoeshine Man. Israel, 1976.

132. Old Man in Beam of Light. Jerusalem, 1976.

133. Alex's Fun Trip to Canada. 2000.

134. Mickey. Minneapolis, 1970. 135. Big Jim (Jim Beattie). St. Paul, circa 1966.

On occasion, while sitting down in my lab taking a little break, I have looked around at all of the old beat-up camera bags, filled with well-worked and well-worn camera gear. Thinking back in a flash to those times of shooting all day, every day. Then I worked with 4 x 5, medium-format, and 35-mm film cameras; now I work mostly with digital 35-mm gear. And life goes on. Technology and trends change faster than runway fashions. My little space, jam-packed full of life experiences through a career as a photographer and observer of life. I have taken much pleasure in observing and recording people; that's seems to be my real joy in photography. Recording everyday life as it happens. Being there in the moment. Yes indeed, I feel that the present is truly a very special gift to the photographer.

136. Grandpa's Saturday Hat. 2001.

137. The Cosmos. South Dakota, 1975.

138. Olivia, Pretty in Pink and a Good Friend of the Tooth Fairy. 2008.

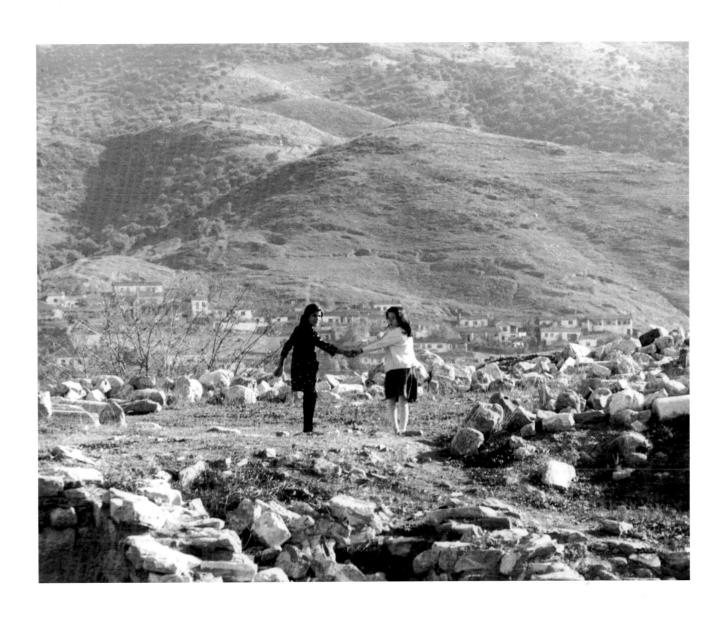

139. A Reflective Moment in the Shade, Jerusalem, 1967.

140. Friends. Outskirts of Ankara, Turkey, 1967.

Roll it all up in a big ball and call it, Life.

Here we come! . . . Here we are! . . . Here we go!

Poof!

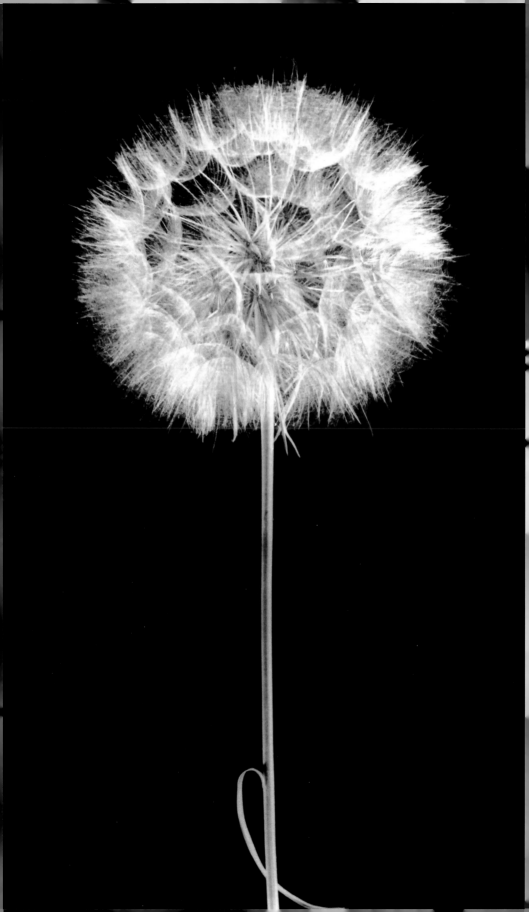

Photo Index

Cover and title page: Fetus, approximately eight weeks old, from an unruptured ectopic pregnancy. 1972.

1. Poof Ball (color). 1973.
2. Bob Wolfe. Photo: Michael C. Wong, Minneapolis
3. Norway, 2001.
4. Joel. To Fly, Caught in Time. 1970.
5. Pensive Man. Jerusalem, 1967.
6. Jockey. South Dakota, 1968.
7. And the Curious Children Stop and Stare, Old Men and Children. Israel, 1967.
8. Gazing with Love and Joy upon the Fourth Generation. 2002.
9. Athens, Greece, 1971.
10. Photographer. Donnybrooke Raceway, Brainerd, Minnesota, 1969.
11. Raymond Hendler, New York School Abstract Expressionist, action painter and pioneer of modern art. 1979.
12. Nicholas Harper, artist and owner, Rogue Buddha Gallery. Minneapolis, 2006.
13. Big Bug. 1989.
14. Pensive Lady. High-contrast flip-flop Kodalith negative from original 35mm B&W negative. 1974.
15. Alex and Elliot. Minnesota Renaissance Festival, 1999.
16. Diane, 1972.
17. Smoke Break. Jaffa, Israel, 1967.
18. West Bank. Minneapolis, 1972.
19. Sign Artist. Israel, 1967.
20. Adam at Sunset. Auguste Rodin's "Adam." Billy Rose Sculpture Garden, Jerusalem, 1970.
21. View of the Dead Sea and Negav Desert, as seen from the serpentine trail on Massada (workers erecting air tram descending for lunch break). Israel, 1971.
22. Homnoy, Norway (Lofoton Islands), 2001.
23. Room with a View. Salmon Glacier, Hyder, Alaska, 1995.
24. Anasazi Cliff Dwelling. Messa Verde, Colorado, 1988.
25. Eiffel Tower. Paris, 1975.
26. Salmon Glacier. Alaska, 1995.
27. Acorns. Patiently lying beneath a beautiful canopy of majestic oaks can be found the seeds or tomorrow's forest. 1971.
28. Bleeding Heart (Lady in the Bathtub). 2008.
29. Good Morning America, How Are Ya? Monument Valley, Utah, 1992.
30. Rock Wall. Alaska, 1995.
31. If Nothing Changes, Nothing Changes. Gaza, 1967.
32. Shopkeeper. Israel, 1967.
33. Laundromat Studio. South Dakota, 1968.
34. Garage Studio. Nebraska, 1968.
35. Joanne at 17. 1981.

36. Little Indian Princess. Nebraska, 1968.

37. Alex—Self-proclaimed Gypsy Princess. ("Yes, I do all of my own makeup.") 2000.

38. Little Girl with a Curl. Israel, 1967.

39. Barrel Man. St. Paul, Minnesota, 1967.

40. Unknown Man. Stevens Point, Wisconsin, 1969.

41. Chuck the Hammer. Minneapolis, 1979.

42. Diane. 1972.

43. By the Wailing Wall. Jerusalem, 1967.

44. Ber-Sheba. Israel, 1975.

45. Cowboy with Team ("Take a big drink, boys.") British Columbia, Canada, 1995.

46. On the Bridge. Oslo, Norway, 2001.

47. Emo, The Fish Wrestler. Ontario, Canada, 1978.

48. *D.M. Clemson* Preparing to Enter the Duluth Harbor under the Aerial Lift Bridge. 1965.

49. *D.M Clemson* Nestled in for the Winter. 1965.

50. Duluth Superior High Bridge and Old Swing Bridge. 1967.

51. Edith Rogers, Co-owner, Rogers Pure Oil Station on East Superior Street, gas 35¢ per gallon. Duluth, 1967.

52. Benjie, Friend from My Youth. 1967.

53. Tom and Goldie Wolfe. Mom and Dad's Wedding Photo. Duluth, 1937. (Photographer unknown.)

54. My Father and Grandfather, on a day trip to Winnipeg, Canada. 1921. (Photographer unknown.)

55. Mom and Dad on Motorcycle with Sidecar. Kibbutz Gesher, Haziv, Israel, 1970.

56. Goldie. Israel, 1970.

57. Father and Sons at the Wailing Wall. Jerusalem, 1970.

58. Diane and Joel—Mother and Son. Minneapolis, 1978.

59. Mom and Dad on my Tenth Birthday. In front of Zenith News. Duluth, 1952.

60. Mom and Dad at the Red Sea. 1970.

61. My sister Neena reading Dad his mail following his stroke. 1986.

62. Elizabeth and Fridtjof ("I always wanted a doll house. He built me one when I was 60.") Å, Norway, Lofoton Islands, 2001.

63. Ben and Barry. Isabella, Minnesota, 2006. It's OK to be romantic and young at heart at any age.

64. Harry and Doris. Valdez, Alaska, 1995.

65. Susan and Sitiva. Fairfax, California, 2005.

66. Diane and Spooky. 1980.

67. Joanne, age 9, with her little 3½-pound pal Spooky. 1973.

68. Joanne, age 23. Saying goodbye to Spooky, her little pal of 15 years, Joanne and Diane. 1986.

69. Alex, Diane and Sonny—Celebrating to the Beat of Life. 2002.
70. Alla Rakha and Ravi Shankar. Stevens Point, Wisconsin, 1969.
71. Alex at 16. Minneapolis, 2009.
72. Ryan. Dundas, Minnesota, 1972.
73. Japanese Taiko Drummers. Minneapolis, 2009.
74. The Thunder Bats. Minneapolis, 1988.
75. Man with Flute. 1969.
76. Diane, in Kata Saifa. 1986.
77. Merrill Jung. San Francisco, 1987.
78. Kata Seinchin. Minneapolis GOJU-Kai Karate School. 1987.
79. Michael Wong. 1986.
80. Tom Dahlstrom. 2003.
81. Mr. N. Gosai Yamaguchi-Hanshi, Chairman GOJU-Kai Karate-Do USA. San Francisco, 1999.
82. David's Home and Office on the Road. *The Truck Book.* 1981.
83. The Winning Run. *Softball Is for Me.* 1982.
84. *Rock Climbing Is for Me.* Taylors Falls, Minnesota, 1984.
85. *Cooking the Japanese Way.* Minneapolis, 1983.
86. *Quarter Midget Racing Is for Me.* 1981.
87. Author Photographing Surgery. University of Minnesota Hospital. 1976. Photo by Sam Cohen.
88. Dr. John Najarian carrying kidney from Donor Room to Recipient Room, circa 1973.
89. Fetus, approximately six to seven weeks old, from unruptured ectopic pregnancy. 1976.
90. The Morgue. 1975.
91. First human heart transplant performed in Minnesota. March 4, 1978.
92. The Badly Damaged Heart, result of a massive heart attack. March 4, 1978.
93. Self-portrait. Setting Up a Studio Shot. 1975.
94. Photomicrograph, normal blood cells and cycle cells, magnification 700x. 1974.
95. Dr. Jim Ausman, Neurosurgeon. 1974.
96. Neurosurgery, retractors shown exposing a tumor at site of the brain stem. 1976.
97. A stage in open heart surgery on a three-year-old child illustrating the repair of a heart valve. 1975.
98. Fetus, approximately eight weeks old, from an unruptured ectopic pregnancy. 1972.
99. Bilibed, phototherapy lamp treatment for newborn jaundice. 1974.
100. Stained Glass Window. Jewish Synagogue. Sosua, Dominican Republic, 2000.
101. Wolfe Racing Team. Bonneville Salt Flats, Utah, 1976.
102. Biomedical photography students observing procedure in research lab. University of Minnesota Health Science Center. 1977.

103. Waiting Out a Rain Storm with a Broken Alternator Belt. Road between Minto and Manley, Hot Springs, Alaska, 1993.

104. Arc de Triomphe, Champs Elysees by Night. Paris, 1970.

105. Negav Desert Overlooking the Dead Sea. 1963.

106. Cowboy. Monument Valley, Utah, 1992.

107. Bar Mitzvah Boy. Israel, 1975.

108. Captain Experimental (unknown pilot). 1968.

109. Guyana Boatman. Essequibo River, Guyana, South America, 1970.

110. Boy with Chickens. Israel, 1967.

111. Pie Boy, Fourth of July. Makana, Wiscosin, 2006.

112. Champion Swimmer. Bartica Guyana, South America, 1970.

113. Young Entrepreneur, circa 1970.

114. Stone Lake, Wisconsin, 2001.

115. And they're off! Stone Lake, Wisconsin, 2001.

116. Stone Lake, Wisconsin, 2001.

117. And they're off! Stone Lake, Wisconsin, 2001.

118. Ice, Maps, Frozen Smelt, and Therapeutic Massage. Grand Marais, Minnesota, 2006.

119. Jerusalem, 1975.

120. Veterans Color Guard, Marching to the Beat of Freedom. Makana, Wisconsin, July 4, 2005.

121. Brother Ben, Peace Corp Worker, on Vacation. Barbados, 1972.

122. Barry—Educator, National Ski Patrol, Fighter of Forest Fires. Lutsen, Minnesota, 1969.

123. Diane—Nurse, Wife, Mother, Artist, Teacher, Friend. 1972.

124. Skin Grafting on a Burn Patient. 1975.

125. Eye Surgery. 1974.

126. Amputated Extremity Lying on Specimen Table. 1975.

127. Mitla Pass, Sinai Desert, 1967.

128. The Death Seat. Sinai Desert, 1967.

129. 9/11/01. Live from New York: 2nd World Trade Center Tower Collapses, 10:28 a.m., 2001.

130. Paper Boy, 4:45 a.m., -12° F., Preparing to Deliver the Sunday paper. Minneapolis, 1975.

131. Shoeshine Man. Israel, 1976.

132. Old Man in Beam of Light. Jerusalem, 1976.

133. Alex's Fun Trip to Canada. 2000.

134. Mickey. Minneapolis, 1970.

135. Big Jim (Jim Beattie). St. Paul, circa 1966.

136. Grandpa's Saturday Hat. 2001.

137. The Cosmos. South Dakota, 1975.

138. Olivia, Pretty in Pink and a Good Friend of the Tooth Fairy. 2008.

139. A Reflective Moment in the Shade. Jerusalem, 1967.

140. Friends. Outskirts of Ankara, Turkey, 1967.

141. Poof! (black and white w/stem)

Selected Bibliography

Brown, Tom Jr., and William Jon Watkins. *The Tracker.* New York: Berkeley Books, 1979.

Campbell, Joseph, with Bill Moyers. *The Power of Myth.* New York: Doubleday, 1988.

Castanada, Carlos. *A Separate Reality.* New York: Pocket Books, 1972.

Frank, Frederick. *Zen Seeing, Zen Drawing.* New York: Bantam. 1993

Frankl, Victor E. *Man's Search for Meaning.* Boston: Beacon. 2006.

Furuya, Kensho. *Kodo Ancient Ways.* Santa Clarita, CA: Ohara Publications, 1996.

Ghibran, Kahlil. *The Prophet.* New York: Knopf. 1966.

Gonzales, Laurence. *Deep Survival.* New York: Norton, 2003.

Herrigel, Eugene. *Zen in the Art of Archery.* New York: Vintage, 1971.

———. *The Method of Zen.* New York: Vintage, 1974.

Karsh, Yousuf. *Karsh, A Fifty-Year Retrospective.* New York: New York Graphic Society, 1983.

Kling, Kevin. *The Dog Says How.* St. Paul, Minnesota: Minnesota Historical Society, 2007.

Lowry, David. *Autumn Lightning.* Boston: Shambhala, 1985.

Nerburn, Kent. *Small Graces.* Novato, CA: New World Library, 1998.

Steichen, Edward. *The Family of Man.* New York: Museum of Modern Art, 1955.

Thoreau, Henry David. *Walden and Other Writings.* New York: Nelson Doubleday, 1970.

Ueshiba, Morihei, trans. John Stevens. *The Art of Peace.* Boston: Shambhala, 1992.

Bob Wolfe

is an award-winning photographer whose career has embraced a variety of genres and interests. Working as a biomedical photographer at the University of Minnesota Hospitals and Health Science Center, he created images for teaching as well as contributed to numerous medical books, journals, and research papers. He developed and taught a course in biomedical photography for the Minneapolis College of Art and Design. His professional work has included portraiture, industrial, architectural, commercial, and photo essay, while also finding enjoyment in photographing nature and landscape. He has authored two children's books and has created the images for over seventy others. He is also an experienced and skilled professional custom color and black-and-white photographic printer.

Having been involved in the martial arts for many years, he holds the rank of Godan-fifth-degree black belt in traditional Japanese GOJU-Ryu Karato-Do and has been a long-time practitioner of Muso Shinden Ryu lai Do—the art of Japanese sword drawing techniques.

He lives in Minneapolis, Minnesota, with his wife, Diane, and their little dog Sonny.

Besides sharing my images,
I wish to extend a subtle message of
hope, understanding, and inspiration
along with a challenge to improve
the quality and outlook of not only our lives
but also that of others.

~

Bob Wolfe
March 16, 2010